Draw a
Fig

16 projects

Bristol Libraries
Renewals 0845 002 0777
www.bristol-city.gov.uk/libraries

Lucy Watson

D0336015

A QUARTO BOOK

Published in 2003 by Search Press Ltd
Wellwood
North Farm Road
Tunbridge Wells
Kent TN2 3DR
United Kingdom

ISBN 1-903975-18-2

QUAR.LDF

Conceived, designed and produced by
Quarto Publishing plc
The Old Brewery
6 Blundell Street
London N7 9BH

Senior Project Editor: Nadia Naqib
Art Editor: Karla Jennings
Copyeditor: Hazel Harrison
Designer: Paul Wood
Assistant Art Director Penny Cobb
Photographer: Colin Bowling
Proofreader: Alice Tyler
Indexer: Pamela Ellis

Art Director: Moira Clinch
Publisher: Piers Spence

Manufactured by
Universal Graphics Pte Ltd., Singapore
Printed by
Star Standard Industries Pte Ltd.,
Singapore

Contents

Introduction

It is not unusual to hear beginners, and sometimes more experienced artists, claim that they can't draw people, or that they never put figures into their pictures because they are too difficult. It seems strange that this very familiar subject, usually the first one that we tackled in childhood, should pose such a problem, but the reason is this very familiarity. You can often get away with mistakes when drawing something unknown to the viewer, but we all know what people look like, so incorrect proportions and misunderstood forms will immediately catch the eye.

Basically, figures are no harder to draw than any other subject – all you need is the will to practise and the ability to analyse what you see and translate it into your own pictorial language. To help you to make a start and gain confidence, a number of artists have shared their experience and knowledge for this book, explaining their techniques in a series of clear step-by step exercises covering various aspects of figure drawing.

You don't need a lot of equipment or an in-depth knowledge of anatomy to get started, and fortunately you will seldom be short of subject matter – if you can't find an

obliging model, you can draw yourself. Don't be put off by fear of making a mistake; think of your first attempts as experiments. Over the years I have accumulated sketchbooks full of drawings, which log my progress from my first tentative grapplings with the subject through a gradual progression as I gained confidence and experience. Keep your sketches so that you can look back at them later – you will almost certainly be surprised and encouraged to find how much better you become as you learn through drawing. Above all, bear in mind that not every drawing will be successful; Henri Mattise was famous for throwing away many more drawings than he kept, and the artists who contributed to this volume discarded quite a few along the way. So good luck, and I hope that this book will help you to discover the pleasure of making successful figure drawings.

Lucy Watson

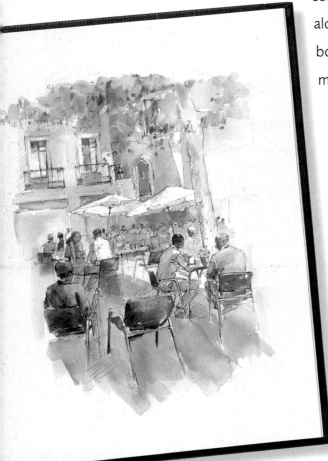

Materials for projects

Below is a list of the materials you will need for each project. Use good-quality drawing paper unless otherwise stated.

Note that coloured pencils and pastels, in particular, are available in a vast range of colours and the names vary considerably from one manufacturer to another. For this reason, pastels and pencils are listed as generic colours (blue, green, for example) rather than as specific manufacturer's shades. Choose the colours from your preferred range that match the ones in the projects most closely.

The size of the brush you use will depend on your own personal taste and on the scale of the drawing you're producing. Brush sizes are therefore given as 'small' or 'medium', to give you a general guideline about what to select.

But don't worry if you don't have exactly the right equipment to hand: these projects are merely a stepping stone to help you develop your own ways of interpreting figures and, as always in art, keen observation is the key to success.

MODEL WITH STAFF • 4B pencil

STUDY OF MALE FIGURE • Bistre hard pastel stick • Cream cartridge paper

SEATED FIGURE • Red Conté pencil • Soft pastels: terracotta, brown • Coloured pencils: light brown, red, orange

GIRL LACING HER SHOE • Charcoal stick • Soft pastels: cream, pale blue, turquoise blue, light brown, light grey, light mauve, dark purple

LEONA IN A SILK ROBE • Brown Conté pencil • Soft pastels: light blue, dark blue

RECLINING NUDE • Mid-grey pastel paper • sanguine Conté pencil and crayon (stick) • Soft pastel: Naples Yellow

DRAPED FIGURE • 4B pencil • White Conté pencil

WOMAN AND CHILD • 4B pencil • Coloured pencils: blue, dark blue, brown, light brown, dark green, light ochre, dark brown, red-brown, red, rose, yellow ochre

WOMAN IN A YELLOW ROBE • 3B pencil • Oil pastels: warm pink, grey, medium grey, cool grey, warm grey, yellow, red, grey-green, pale orange, warm orange, dark orange, ochre, cool blue, warm blue, blue, purple grey, pale brown

HEAD STUDY • Brown Conté pencil • Coloured pencils: blue, red

HANDS AND FEET • Sanguine Conté pencil • Charcoal stick • Ink pen

MALE AND FEMALE EYES • Charcoal pencil • 2B pencil • Brown Conté pencil • Coloured pencils: blue, green

EARS, NOSES AND MOUTHS • Conté pencils: brown and terracotta • Coloured pencils: light brown, red • Charcoal pencil • Soft pastel pencil: terracotta

CAFÉ SCENE • Watercolour paper • Medium sable brush • Watercolour paints: blue, blue-grey, brown, green, red, red-brown, terracotta, yellow

BALLOON ARTIST AND CHILD • 4B pencil • Soft pastel pencils: black, grey, red, pink-red, yellow, light pink, dark pink, light blue, dark blue, purple, light purple, green

MARKET SCENE • Technical pen

Getting started

In our crowded world, we are surrounded by figures, so you will never find yourself short of models, and you need very little equipment to begin with – a sketchbook and a few pencils or a ballpoint pen and perhaps some sticks of charcoal should suffice. It is best to stick to monochrome initially unless you already have some experience of working with colour, or you may find yourself wrestling with the media rather than the subject.

Sketching on location

If you decide to begin with outdoor sketches, use a fairly small sketchbook so that you don't look too conspicuous – it can be unnerving having people looking over your shoulder and passing remarks. Don't set yourself the problem of coping with fast movement for your initial attempts; look for places where people may be reasonably static, such as parks or beaches in summer. Try to work fairly rapidly but without rushing, and avoid the temptation to erase; if a line is wrong or a person moves before you have finished, simply draw more lines over the first. These sketches should be regarded as practice exercises rather than as finished pieces. Once you have built up some confidence, take your sketchbook with you at all times, as you never know when you may see a good subject. You could also use a camera to make visual notes; although it is best to work from life for figure drawings, the camera has its uses when you don't have time to sketch.

Basic kit *A pencil, rubber, ballpoint pen, ink pen and some drawing paper are all you need to get started.*

Working indoors

If you have a family member or friend who is willing to sit for you, you can carry out more finished drawings, though do bear in mind that holding a pose for a long period is tiring, so give your model a rest at regular intervals. Have a piece of chalk or some tabs of masking tape handy to mark the position of the sitter's feet, and the hands if they are resting on the arms of a chair, so that they can resume the same pose after the break.

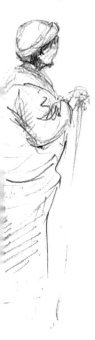

You might consider working on a larger scale for indoor drawings – you can either use an A3 sketchbook or drawing paper on a board. But this is a personal choice – some people are comfortable with a small scale while others find their drawings rapidly expanding beyond the boundaries of the paper. You will quickly discover your natural working size, and if you find you like to work large, you would be well advised to try out a different medium, such as charcoal. Pencil is a wonderfully versatile medium for small to medium-sized work, but charcoal allows for broader, bolder effects, and allows you to build up form rapidly.

Paper for art
Papers are available in a wide range of textures, weights, colours, sizes and absorbencies, giving the artist an inspirational choice of surfaces on which to work.

Pencil sketches
The humble graphite pencil is an ideal medium for making gentle and discreet sketches of people going about their everyday lives.

Figures in context

Drawings of people at work, or doing something typical of them, are often more interesting than static poses, and can be more rewarding to draw, as you will be providing a context for the figure and telling a visual 'story' about them. Try drawing someone preparing food in a kitchen, reading a paper, tending plants in a garden, or children drawing or watching television. An advantage of this kind of study is that the 'model' will be absorbed in the task or activity and won't be self-conscious. If you are part of an art group or attend a class, draw your colleagues bent over their drawing boards. And finally, if you have no model to hand, draw yourself at work – many artists have made fascinating drawings and paintings of themselves at their easels. Drawing requires practice, and you will succeed if you keep at it.

Fishermen at work
This watercolour sketch captures the immediacy and atmosphere of young fishermen at work on a bright summer's day.

the **Fundamentals**

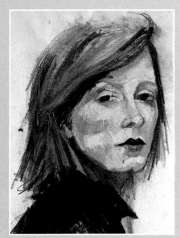

This section of the book outlines the basic principles and techniques that are fundamental to drawing and sketching figures. The section is divided into subject areas such as Understanding the Figure or Movement, and the information is conveyed through simple step-by-step exercises.

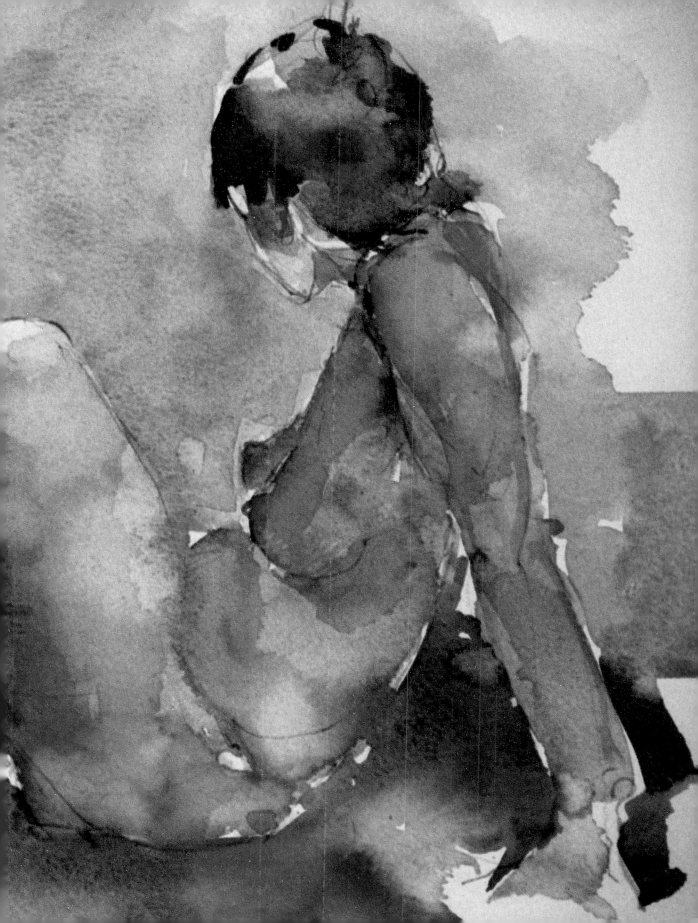

THE FUNDAMENTALS
Understanding the figure

You don't need an in-cepth knowledge of anatomy to get started on figure drawing, but it does help to understand the proportions of the body, the basic skeletal structure and the way the muscles and flesh clothe the bones. You can find out a great deal simply by looking at yourself and observing carefully.

Be your own model

The shins and ankles have a relatively light covering of muscle and flesh, so you can observe the bone structures of the lower legs simply by looking down at them. You can also look at the structures of hands and feet without any difficulty, but to 'learn' the body properly you want to see it as a whole. So if you have access to two full-length mirrors – and a private place where you won't feel self-conscious – you can model for yourself. This is a good way of familiarising yourself with the shapes and structures before you start drawing. Try to be as objective as possible, thinking of your body as a structure rather than as a reflection of yourself.

Human skeleton
The male skeleton is larger, narrower across the pelvis and broader across the shoulders than the female skeleton. The bone structure within one sex is relatively similar between individuals, but the muscular and fleshy covering can differ dramatically from person to person.

Observing movement

Gently flex your limbs this way and that to see how the 'scaffolding' of the body is affected by movement. Roll your head gently, trying to feel the weight and volume, then move gradually downwards, lifting and dropping the shoulders, and then concentrating on the muscles that come into play when you raise and lower your arms. Continue moving down your body and out to your hands, noting how the skin responds by stretching and folding in response to movement, and how joints rotate only so far. Try standing with your weight on one leg, and observe the changes that take place to counter-balance the weight adjustment. The weight-bearing leg automatically aligns with the head, the weight-bearing hip is pushed up, and the shoulder over that hip slopes downwards. Don't force any movement – the point is to discover the natural limitations of the muscle, tendons and skeletal structure.

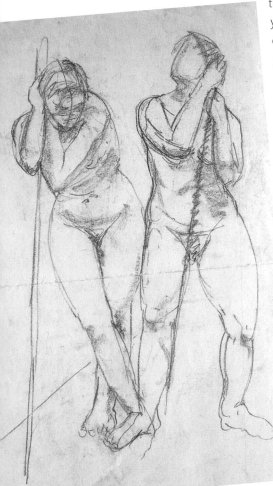

Different viewpoints *By asking her model to hold a staff, the artist was able to capture the figure in a number of complex and interesting poses.*

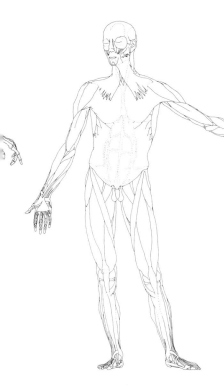

Measuring proportion with a pencil

You can use your pencil as a yardstick with which to make comparative body measurements. To do this, simply concentrate on your model, then hold the pencil vertically out in front of you on an outstretched arm. Close one eye and place the end of the pencil (the end opposite the lead tip) so that it is level with the top of the head. Move your thumb to mark on the pencil the point that lies at the bottom of the head (usually the chin) and hold the measurement of your pencil there.

Now focus on the pencil. The length of pencil you see before you gives the proportionate (not actual) head length by which you can measure the rest of the figure in relation to it. Still holding your head length measurement with your thumb, place the top of the pencil at the bottom of the head and make a mental note of where your thumb now lies in relation to the figure – it is probably somewhere in the middle of the chest. Repeat this process down the body until you reach the feet. You should calculate that the head length you have measured fits approximately seven-and-a-half times into the body.

Muscular forms *Careful observation of the undulating flesh of the body (see above and below) will reveal some of the complex pattern of muscle beneath the skin.*

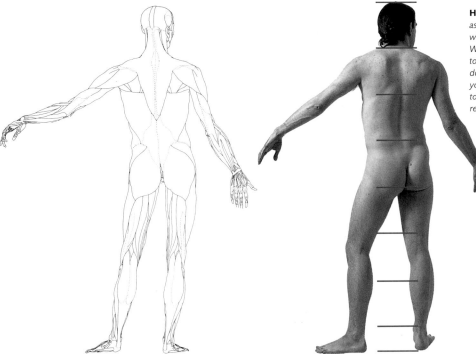

Head measure *The head is normally used as a yardstick for the proportion of the body, which is about seven-and-a-half heads high. When you begin drawing, hold up a pencil to measure the head, then make small marks down the paper for the rest of the body. If your subject is a child, the body will be five to six heads high as a child's head is larger in relation to its body size than an adult's.*

EXERCISE I

Model with staff

by Lucy Watson

When drawing a standing figure, it is vital to get both the balance and the proportions right, so that the figure doesn't appear to be toppling over sideways or resting the body's weight on feet that are too small to bear it. The aim of this exercise is to learn how to plot the key lines accurately, using a pencil and ruler to take measurements and check the balance lines. When a pose can be held for a reasonable length of time, analyse it before committing marks to paper. You may find it helpful to assume the same pose yourself for a few minutes, so that you can feel how the weight is distributed – in this case much of the upper body weight is resting on the left leg. The artist is working in graphite pencil.

Practice points
- MAKING A MEASURED DRAWING
- BALANCING THE FIGURE
- CHECKING NEGATIVE SHAPES

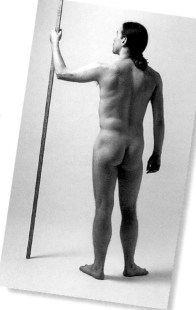

STAGE 1

PLOTTING THE KEY LINES

■ By aligning the edge of your ruler against the model, you can see that an almost straight vertical line runs through his head and down through the left leg. This not only provides you with the vital line of balance but also becomes a useful yardstick for the proportions. The head will fit about seven-and-a-half times into this length, so measure the head with your pencil (see page 11) and make a series of light marks down the line. The last mark will give you the overall height of the standing figure, finishing at the bottom left heel. At this point you can decide whether you need to make the head, and consequently the rest of the figure, larger or smaller in relation to your paper size.

sketch in the head, then use a ruler to draw in a faint line running from the centre and down through the weight-bearing leg. This 'plumbline' shows how the left leg supports the upper weight of the figure in a straight, rod-like fashion, while the right foot is relaxed, moving out at an angle at the front of the body.

Use the ruler again to check the relative position of the feet. Align it roughly with the centre point on the left and right heel, and you will see that the right heel moves away from the left at approximately a 20-degree angle to rest a little out in front. Make a reference mark, and then sketch in the right heel.

Hold the ruler horizontally to check that the position of the top of the left hand falls just below the level of the top of his head. The armpit is about level with the second 'head length' mark on the vertical line, while the right hand ends at a point just below the right buttock. Make marks for all these comparative measurements, as they form important reference points to help you get the proportions right and position the limbs accurately.

STAGE 2
CONSTRUCTING THE DRAWING

■ Continue to take more measurements against the model, checking proportions and angles until you are satisfied that they are correct. In this method of measured drawing, the figure is constructed rather like a piece of scaffolding. It may seem laborious at first, but with practice your eye will become attuned to the process and it will become more natural. Simpler poses may require fewer measurements, while more difficult ones such as foreshortened figures may need even more.

Once you are sure that the basic proportions and angles are correct, you can draw in a stronger outline to flesh out the figure.

As you draw in the contour of the figure, look closely at any spaces between the limbs, which are known as 'negative shapes'. If one of these shapes looks wrong, it means you have not placed the limbs correctly and will need to make adjustments.

Align the ruler with the centre of the right leg to check its position in relation to the body, then flesh it out around the straight line.

STAGE 3
WORKING UP THE DRAWING

■ Once the main 'scaffolding' in is in place, you can proceed with the drawing in a freer style. Erase the main ba ance line, as it has now served its purpose, and if left in place would confuse the drawing and interfere with its progress.

When the body begins to look solid and convincing, you can turn your attention to the more intricate details of the face, hair, and hands.

Strengthen the outlines in places, but don't make them all of equal weight, and add tone where appropriate. The stronger lines and areas of light shadow suggest the solidity of the forms turning away from the light.

STAGE 4
CREATING VOLUME

■ To complete the study, you will need to concentrate on light and tone, building up the forms to create the feeling of three-dimensional volume. Before you begin to add shading, erase any obvious earlier guidelines. The remainder are likely to disappear beneath tonal work.

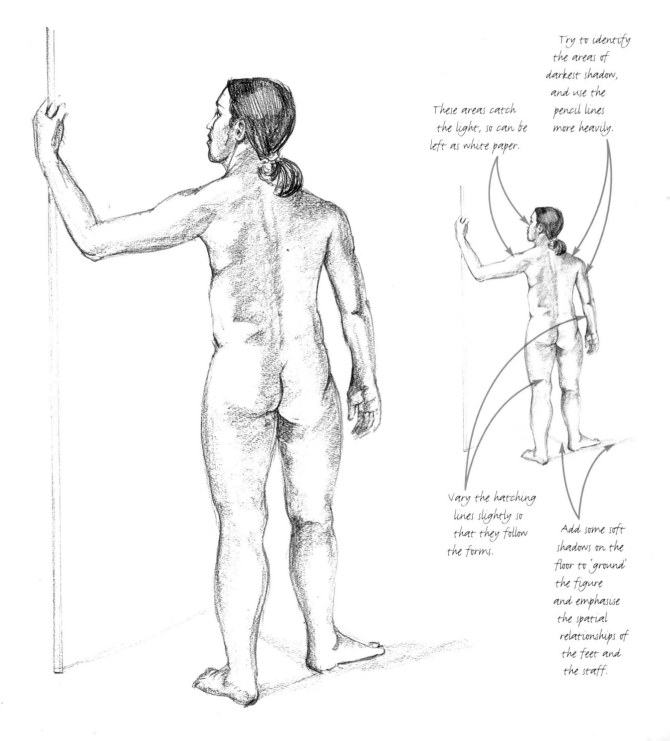

Try to identify the areas of darkest shadow, and use the pencil lines more heavily.

These areas catch the light, so can be left as white paper.

Vary the hatching lines slightly so that they follow the forms.

Add some soft shadows on the floor to 'ground' the figure and emphasise the spatial relationships of the feet and the staff.

EXERCISE 2

Study of male figure
by Barry Freeman

This exercise demonstrates body dynamics or the movements that are specific to the human anatomy. The human form is capable of an enormous range of movements, such as stretching, balancing, flexing, and twisting, although there are limits even to what a dancer or an acrobat can do. Getting the body dynamics wrong will not only make your figure look awkward, it can be difficult to rectify. However you can simplify the drawing process by using your pencil as a tool by which to take measurements and check angles. The artist is working with a square-sectioned hard pastel stick, and combining linear shading methods with broader sweeps made by holding the pastel on its side.

Practice points

- ANALYSING LINES OF MOVEMENT
- ANALYSING TONE
- DIFFERENT METHODS OF SHADING

STAGE 1
DRAWING THE OUTLINE

■ Before you begin drawing, align a pencil with the various parts of the subject's body to understand the main lines of movement, as these are vital in conveying the twist of the torso. In this pose, a straight line can be made against the right side of the torso running through the right foot. Two more straight lines fan away from this vertical (see below).

It is common to start with the head in figure drawing, but in this case it is only partially visible, so it is more important to establish the line of the shoulders.

Use the edge of the pastel stick to sketch in the main lines of the figure, lightly indicating the chair. Pay special attention to angles as these are vital in conveying the twist of torso.

Draw a light guideline from one hip to the other and from the top of the thigh to the bottom of the right buttock

Hold up a pencil (see page 11) to check important angles, such as those of the chair and spine.

STAGE 2
INDICATING SHADOW

█ It is a good idea to stand back from your work to check whether you need to make any more changes to the 'scaffolding' before taking the drawing to the next stage as it will be more difficult to make any major corrections later on. When you are sure that the positions of the body and the chair are correct in relation to one another, define the chair more firmly and indicate some of the softer shadow areas, using the pastel on its side.

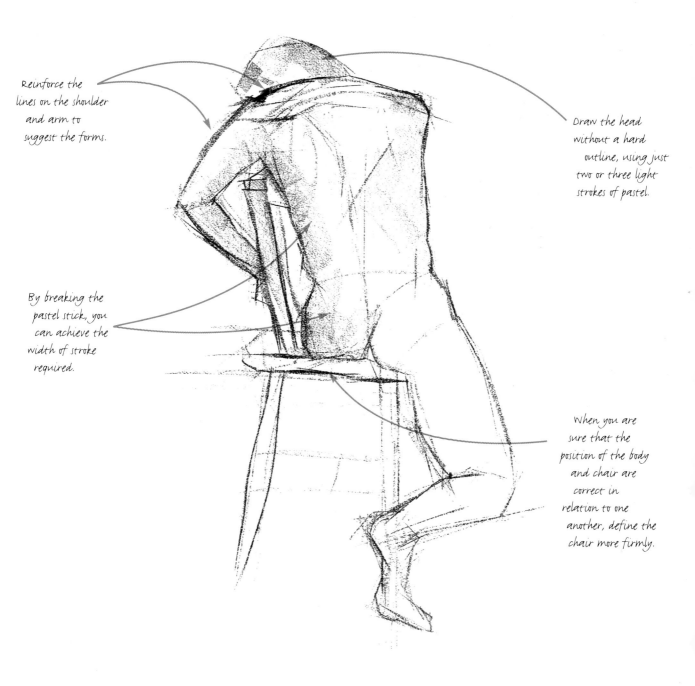

Reinforce the lines on the shoulder and arm to suggest the forms.

Draw the head without a hard outline, using just two or three light strokes of pastel.

By breaking the pastel stick, you can achieve the width of stroke required.

When you are sure that the position of the body and chair are correct in relation to one another, define the chair more firmly.

STAGE 3
STRENGTHENING THE MARKS

■ Gradually build up the tones, making stronger marks in places, especially around the right foot and the cleavage between the buttocks, then add more shadow to the chair. Leave your initial guidelines in place in case any last minute changes need to be made.

TIP
By looking at your work in the reflection of a mirror, any mistakes become more obvious.

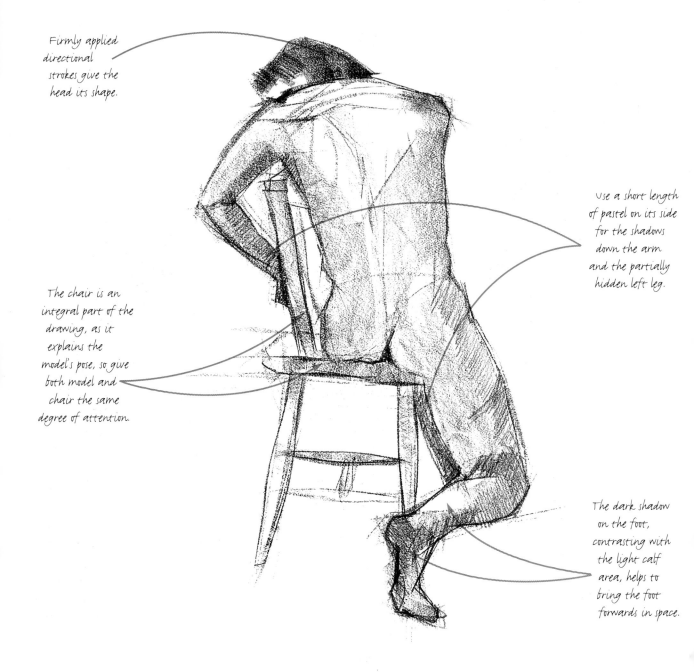

Firmly applied directional strokes give the head its shape.

Use a short length of pastel on its side for the shadows down the arm and the partially hidden left leg.

The chair is an integral part of the drawing, as it explains the model's pose, so give both model and chair the same degree of attention.

The dark shadow on the foot, contrasting with the light calf area, helps to bring the foot forwards in space.

STAGE 4
LINEAR SHADING

■ For the final stages, concentrate on the deepest shadow areas, sharpening up the tonal contrasts with firm pressure on the pastel sticks. Don't go on for too long, however, or you may begin to flatten the image and lose the form.

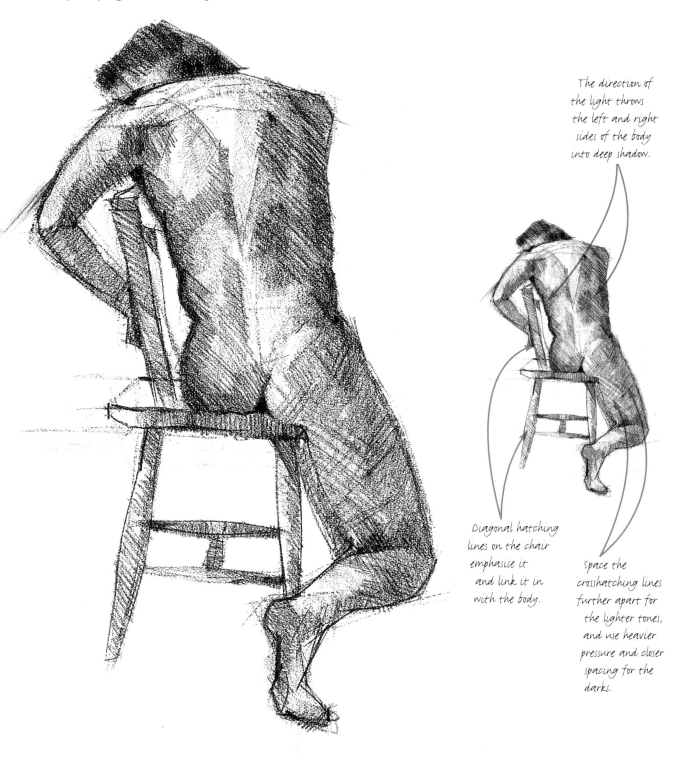

The direction of the light throws the left and right sides of the body into deep shadow.

Diagonal hatching lines on the chair emphasise it and link it in with the body.

space the crosshatching lines further apart for the lighter tones, and use heavier pressure and closer spacing for the darks.

THE FUNDAMENTALS

Perspective in figure drawing

It is commonly believed that perspective is only important for subjects such as architecture and still life, but although it is less complex in the case of figure drawing, it is still important, and you will need to observe its effects very carefully if your drawings are to appear realistic. It is easy enough to apply the rules of perspective when dealing with geometric forms, but rules relying on straight lines and vanishing points are not very helpful in figure drawing, as there are no straight lines. You can, however, reduce the figure down to simple shapes to help you.

Diminishing size *This photograph shows very clearly how objects near the viewer appear larger than objects further back.*

Diminishing size

The most important rule of perspective is that objects appear smaller the further away they are. In terms of figure drawing, it is easier to think of this as the other way around: The part of the body that is nearest to you looks largest. A good example would be a person with an arm stretched out towards you, where the hand and forearm would appear larger than the head. Similarly, a model lying on a couch with her head towards you would appear to have smaller feet in relation to the head.

Basic shapes
Wooden figure maquettes, available in most art shops, show you how the human body can be reduced to basic cylindrical shapes.

Foreshortening

Both the hand and the head in these respective examples will also be foreshortened; that is, they will appear compressed because they are seen in perspective. If you look at a simple form such as a box from directly above, you will see its true proportions, but if you place it on a table that is level with your eyes, the top of the box will appear to have shrunk. It is the same with parts of the body. In most poses, some parts of the body will be foreshortened. A standing figure viewed from the front will appear to have shorter feet, while a seated figure seen from the front will seem to have shorter thighs.

Foreshortening *Note the pattern of shapes this foreshortened pose presents and how the upper arms appear longer than the thighs when viewed from this position.*

Negative shapes *To help you draw a figure correctly, look for the 'negative' shapes between parts of the body (shaded, left). These shapes are often simpler than the 'positive' ones of the figure itself and are a useful double-check when drawing.*

Believing what you see

It is often difficult to believe the evidence of your eyes, as the effects of perspective and foreshortening can be dramatic. The main problem arises from preconceptions; we know that heads are bigger than feet, and that thighs are longer than hands, and t is hard to accept that in some cases they may not look that way. It is essential to learn to believe what you see, and if you have doubts, take measurements, using the pencil and thumb method (see page 11).

Tips for successful drawing

Something people do not always realise is that perspective relies on a consistent viewpoint, which is your own eye level, so remain in the same place and position while you are drawing. If you start drawing a foreshortened foot while sitting down and then stand up, your higher eye level will make the foreshortening effect less pronounced. Moving to one side, even very slightly, will also change the perspective; you can check this simply by looking at an object and then taking a step to right or left.

Interpreting shapes *The simple shapes in the sketch (far right) demonstrate how the three-dimensional form of the girl seated on the chair (right) can be interpreted.*

EXERCISE 3

Seated figure
by Lucy Watson

One of the problems with drawing foreshortened figures is that we tend to draw what we know, and since the figure is such a familiar subject this can lead to problems. We know the length of a thigh, for example, and it is difficult to accept how much it can be affected by perspective. A good way to start is to try to rid yourself of preconceptions and reduce the figure to a set of basic shapes. In this way you can construct a simple 'scaffolding' to establish the directions of the torso, head and limbs and their relationship to one another. And don't forget that if something looks wrong, you can use your pencil to take relative measurements (see page 11). The artist is using coloured pencils, with the main lines of the drawing plotted out in red Conté pencil and further colours used for the shading.

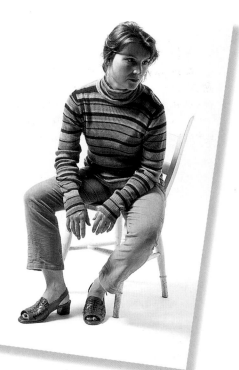

STAGE 1
ANALYSING THE POSE

■ The model sits facing the artist, with the foreshortened aspects of the pose being most apparent in the lower arms, the left thigh and the left foot, which move towards the viewer and are thus seen in perspective. Reducing the whole body to simple cylinder shapes, with the head as an egg shape, helps you to establish the important angles and position the components of the figure correctly.

Practice points
- UNDERSTANDING PERSPECTIVE
- CHECKING BY MEASURING
- LOOKING FOR VISUAL CLUES

Draw a guideline down the centre of the head, imagining it as vertically bisecting the nose. This gives you the angle of the face and head and helps you to place the features.

The upper arms hang down vertically, while the lower arms come towards the viewer, as does the upper chest.

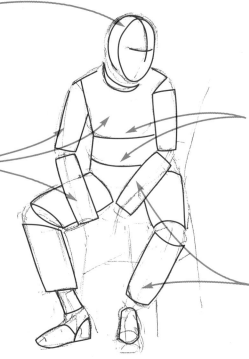

The torso can be roughly divided into two large, flattened cylinders, one representing the stomach and pelvic area, the other the chest. It helps to include a few faint lines moving around the torso to suggest the form. The top guideline here also marks the position of the breasts.

When you have drawn the basic cylinders, pay attention to the bottoms of the sleeves and trousers, as these will give you important clues about the perspective of the limbs.

STAGE 2
CHECKING AND DEVELOPING

■ Once the rough outline is in place, you can begin to develop the drawing, but first take some measurements to check that the positioning is accurate. For example, use your pencil to compare the distance between the two knees, the two large toes and the thumbs. Align it with each of the limbs to check the direction, and make double checks by looking at the negative shapes between the legs and between the right arm and body.

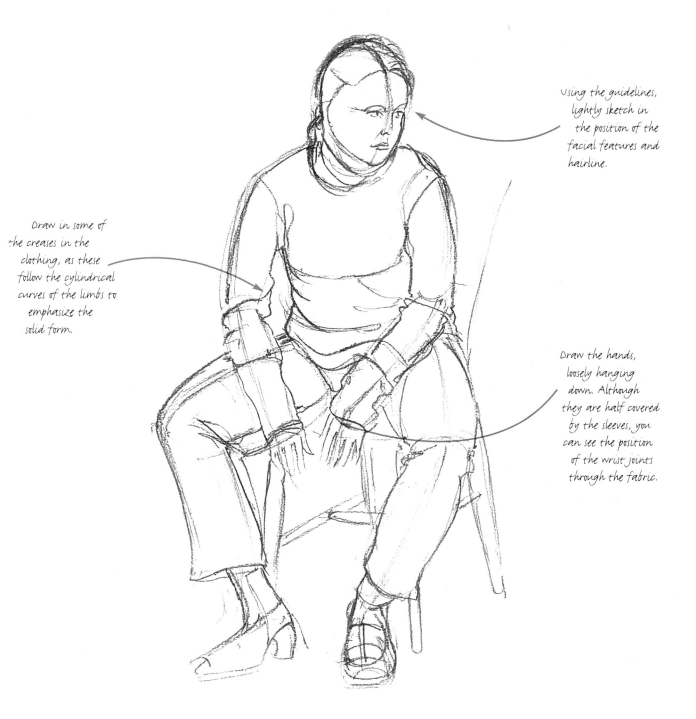

Using the guidelines, lightly sketch in the position of the facial features and hairline.

Draw in some of the creases in the clothing, as these follow the cylindrical curves of the limbs to emphasize the solid form.

Draw the hands, loosely hanging down. Although they are half covered by the sleeves, you can see the position of the wrist joints through the fabric.

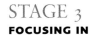

STAGE 3
FOCUSING IN

■ Now that the proportions and angles have been checked and the limbs positioned correctly, you can move onto the more enjoyable part of the drawing, focusing on the details and the model's individual characteristics. Build up areas of tone gradually, as coloured pencil is difficult to erase, so any heavy shading is best left until the final stage.

For pale tones, space out the hatching lines and use light pressure. For darker ones, make the lines closer together, crosshatching for the darkest tones.

Draw the hair with curving lines, leaving highlights where the light catches it from the side.

Add more definition to the feet, again looking for the main shapes. The right foot, with the wedge heel, forms a triangular shape, while the shoe of the left foot forms an arch. Draw this shape first, as it gives you a reference for the sides of the shoe as they curve out and up towards the ankle.

STAGE 4
COMPLETING THE DRAWING

■ The original construction lines have already been obscured by subsequent overdrawing so that the drawing has begun to look more realistic. Now all it needs is some shading and a touch of colour to bring the work to life anc give the feeling of mass and volume.

Build up the hair more strongly, using the brown pencil to emphasise the waves and contrast with the light-struck side of the face.

Use two or three different hues of red and orange for the stripes of the sweater, and take care with the placing of the stripes, as these provide contour lines that explain the forms beneath.

Darkening the bottom part of the left leg helps to make it recede in space.

To build up the forms of the legs, make hatching lines with a brown pencil, darkening the tones by crosshatching. Notice how the areas of shadow under the arms follow the forms of the legs.

EXERCISE 4

Girl lacing her shoe

by Lucy Watson

This apparently simple and natural-looking pose presents more of a challenge than would at first appear. The thighs, especially that of the left leg, are foreshortened, and the right leg has three lines of direction, with the foot and knee brought sharply up towards the body. The feet are at different angles – the left one bent over at the ankle and the right one turned up to facilitate the lacing of the boot, so that the sole of the boot provides the main means of describing the foot. The foreshortened shoes can be reduced to a set of basic shapes as shown. The artist is working in charcoal on pale grey paper, with additions of pastel colour, and she keeps the style loose and free to capture the transitory nature of the pose. Charcoal is an excellent medium to use first as it can be easily erased and reworked.

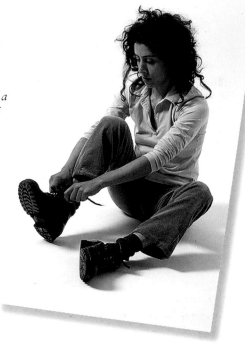

STAGE 1

ESTABLISHING THE POSE

■ Lay down the main lines with a fine stick of willow charcoal, working boldly to capture the main lines of movement. These are most pronounced in the rise and fall of the legs as they come out towards the viewer. If you make a mistake, simply rub off the charcoal lines with a rag.

Practice points

- CHECKING FORESHORTENED PROPORTIONS
- LOOKING FOR CONTOUR LINES
- KEEPING THE DRAWING FRESH

Although the legs are partially hidden beneath the trousers, you can clearly see the knee joints, and follow the line down to place the ankles and feet.

The thigh is very much foreshortened, and the lower leg obscures what is visible. You can establish the direction with just one curving line going around the form.

Take care not to make the feet too small. The average foot is about the same length as the head.

STAGE 2

MAKING ADJUSTMENTS

■ Once the pose has been roughly established you can make any necessary adjustments to tighten up the placing of the limbs and torso, and then begin to flesh out the drawing.

To check the positioning of the arm in relation to the body, look at the 'negative shape' between them. If this appears wrong, you will need to make adjustments to the positive shapes.

The shoes could prove the most challenging aspect of this pose. Break them down into simple shapes – the soles create arc-like shapes while the upper parts appear triangular.

When drawing clothed figures, look for clues that help describe the forms. The folds on the arms of the shirt, and the tops of the socks, go around the forms, providing useful contour lines.

STAGE 3
TIGHTENING UP

■ The drawing has now reached a stage where you can begin to refine details, checking shapes and proportions as you go. Pay special attention to the tightening and slackening folds of the clothes, as these play an important part in describing the stresses evident in this posture.

Don't be afraid to make corrections – notice that the artist has erased some lines after checking the negative shape between the right arm and the body.

The addition of folds in the clothing helps to explain the forms beneath. The trousers hang loosely down from the knees but pull tightly over the thighs.

Work over the left hand so that it looks more like a fist as it pulls on the shoelace.

STAGE 4
BUILDING UP THE DRAWING

■ You can now take the drawing a step further, working on the hair to add some visual interest, and starting to add colour. Don't overdo the colour at this stage, as you don't want to obscure the all-important drawing lines.

Describe the hair texture with thick and thin squiggling lines of charcoal, varying the pressure on the stick

Use the pastel lightly, concentrating on the folds of the shirt and the main shadow areas.

Keep checking at every stage. The artist uses a pencil as a measuring tool to check the height of the left shoe against the size of the head, and finds that proportions are correct when seen from this angle.

Use the charcoal stick on its side to lightly block in some shadow beneath the model.

STAGE 5
USING COLOUR LIGHTLY

■ Because this is primarily a linear drawing, the artist keeps the range of colours to a minimum, using just three light hues of soft pastels: pale blue, light mauve and a flesh tint, plus a brown for the hair. She departs from reality by deliberately using lighter tones than those seen, as the bright, fresh hues help to convey a sense of liveliness that emphasises the brief nature of the pose.

Add some light mauve to the trousers, using the point of the stick to draw in the folds, and varying the pressure from light to heavy.

Fill in the shirt with the pale blue pastel, but use it very lightly to allow some of the light grey paper colour to show through, keeping the drawing fresh.

STAGE 6
COMPLETING THE DRAWING

■ It is important to know when to stop, as overworking the drawing would sacrifice the feeling of spontaneity. Only the face and arms remain unworked, but they can be shaded in very lightly with the flesh-tint pastel, in keeping with the treatment of the clothing The hair needs to be given more emphasis, and some final touches of colour put on the clothing.

Block in the hair with light brown, leaving highlights to reflect the piled mass of dark ringlets. Add a few wisps and tendrils to suggest the texture and prevent the mass of hair from looking too heavy.

Lay some light flesh tones on the face and arms, and work over the facial features again to capture something of the model's individual character.

Emphasise the forms of the legs with some loose hatching lines following the directions of the folds. Curve the lines more at the bottom of the thigh to indicate the rounded form with the fabric pulled tightly over it.

Movement

Although people will often keep still for long periods, as when reading, sunbathing or engaged in some other quiet occupation, it would be a mistake to limit yourself to such subjects, as rewarding as they can be. The human body is designed for movement, and at some stage you will want to capture this in your drawings.

Line quality

The first challenge is deciding how to 'translate' movement onto your sheet of paper so that the figure or figures appear to live. Remember that although a drawing is essentially a flat, two-dimensional image, it need not appear static, and the way you use line can give a good impression of vitality and dynamism.

If you are drawing in a life class, the instructor may start the session with a series of quick poses, which will help you to loosen up and discover different ways of drawing. For quick poses, you might try using a single continuous line or the side of a charcoal stick to follow the direction of the movement. For even shorter poses, it may take several lines drawn in quick succession to give the impression of movement. Whichever way you work, the knowledge that your time is limited will help you focus on the essentials to the exclusion of less relevant details.

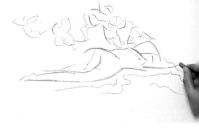

Learning from others *To practise capturing movement in your sketch, try working from a picture that displays movement and energy. This will allow you to capture the main 'sweeps' of movement, as shown here with the aid of a Conté stick.*

Watercolour and light *A pencil sketch captures the frantic activity of the washing scene, while the use of watercolour gives the work its verve and lively lighting effects.*

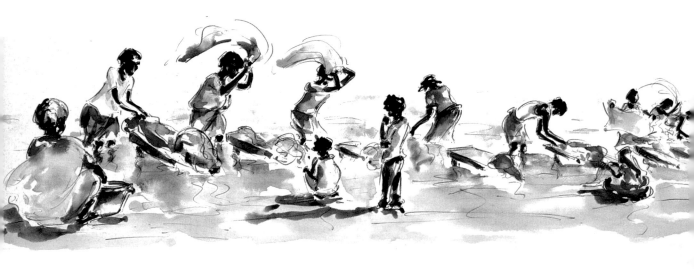

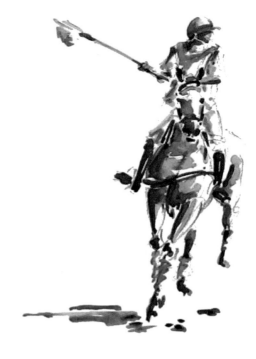

Illusion of movement *A combination of dramatic highlights and loose, boldly coloured brushwork wonderfully describes the fierce movement of both horse and rider in this watercolour sketch.*

Practice makes perfect

At first, the figure in movement can be an alarming subject, but you will quickly overcome your inhibitions if you practise. Always take your sketchbook when you are out and about, and make rapid sketches of people doing their normal activities – walking, running, gesticulating or even playing some form of sport, such as tennis or football. You might also ask a friend to pose for you, perhaps walking across a room, or holding a short pose and then moving on to another one. You may find you can convey the sense of movement better by making several small sketches on one sheet of paper, thus providing a minute-by-minute record of the movement, and giving the drawings a quality of animation.

Working from photographs

Photographs freeze movement, so they are not the best source from which to work. They do, however, help you to analyse movement pose by pose. The way animals and human beings move was not fully understood until Eadweard Muybridge produced his famous series of photographs in the late 1800s. So if you are interested in the movement aspect of figure drawing and have become confident in your techniques for expressing movement, you might try drawing from photos, using the same kind of fluid and uninhibited lines as when working from life. This will involve a considerable degree of self-discipline, as you will not in this case be working against time, but you may find it a useful and challenging exercise.

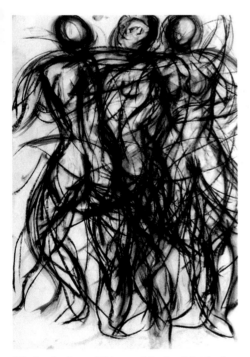

'Study of a dancer' *This powerful series of sketches in Conté chalk and acrylic wash conveys an unmistakable sense of rapid, light-footed and repeated movement.*

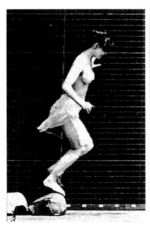
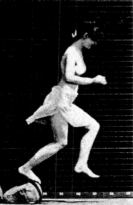
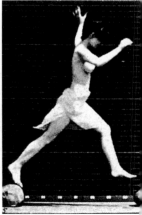

Studying photographs *By freeze-framing movements that occur in a fraction of a second, the British photographer Eadweard Muybridge was able to show how body shape alters with each passing movement.*

EXERCISE 5
Leona in a silk robe
by Lucy Watson

For this exercise the model was asked to take up a series of short poses, none lasting more than ten minutes and some considerably less, all to be drawn on the same sheet. The main purpose of this kind of drawing is to give the impression of a sequence of movements – in this case walking, turning, stooping and finally crouching – but short poses are excellent practice in themselves, as the knowledge that time is limited helps to focus the eye on the essentials and capture a sense of immediacy, preventing your work from becoming static and bogged down in detail. They also help to train your memory, which is an important factor in drawing a moving subject.

<div style="border:1px solid">

Practice points
- CAPTURING THE ESSENTIAL
- LOOKING FOR VISUAL CLUES
- GIVING A SENSE OF MOVEMENT

</div>

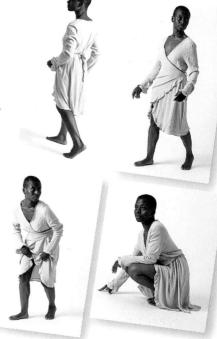

STAGE 1
THE FIRST POSE

■ The model walks in from the right, and then holds the pose for a few minutes. The loose-fitting robe has been chosen to capture something of the flow of movement, so look for the folds of the drapery as well as the main contours of the model. Sketch the main lines quickly with Conté pencil. Then sketch in the areas of light and shade falling on the robe using a light blue and a dark blue pastel.

The top of the robe gives a useful line describing the angle of the shoulders, from which you can plot the position of the arms.

Notice how the robe swings out from the waist as the model moves.

The robe obscures the thighs, but you can guess at the proportions using the visual clues provided.

STAGE 2
THE SECOND POSE

■ The first pose is dropped, and the model walks forwards and turns towards the artist, again holding the pose briefly. When drawing short poses, the key is not to panic – get down as much as you can before the model moves, and don't try to return to a sketch and polish it at this stage. You can work over all the sketches later, when the figures are in place on the page.

There is only enough time to add the briefest of facial features. It is more important to suggest the form of the head than it is to concentrate on the subtleties of facial detail.

Pay close attention to the direction of the light falling on the model as she turns into shadow. Use loose hatching to describe tone on the head and legs.

STAGE 3
THE THIRD POSE

■ The next pose, a stooping one, is by far the most demanding for the model, and can only be held very briefly. The sketch must thus be completed as quickly as possible, focusing on the main downwards movement. Don't worry too much about proportions, but try to capture the scrunched-up look of the body, as the model bends at the waist and knees.

TIP
A putty rubber can be pulled into a point and used in the same way as a drawing implement. It is especially useful in charcoal drawings, as charcoal marks lift off very easily.

Use the Conté pencil and blue pastels to describe the roughly gathered materials of the robe.

You can give a stronger sense of movement, suggesting the succession of poses, by deliberately overlapping the figures.

STAGE 4
THE FINAL POSE

■ The model crouches for the final pose, holding the position for ten minutes. Although this gives you more working time, it is important to maintain the continuity of style, so keep the work simple and sketchy. The extra time will give you a chance to work over the whole sheet of drawings so that the individual studies hang together as a whole. You can do this even when the model is no longer present, but concentrate on movement rather than detail.

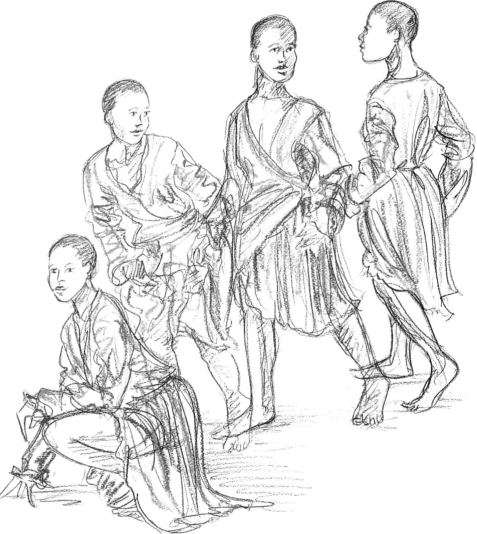

Reinforce the folds of the model's robe using the dark blue pastel, paying close attention to the contour of the limbs beneath. Although the figure is static in each of the poses, the robe's fabric plays a vital part in conveying the illusion of lively, transient movement.

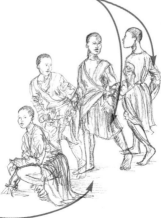

Using the Conté pencil, work some more areas of tone to 'ground' the figures and make them stand out from the background.

Light, tone and volume

Powerful and expressive drawings can be made in line alone, but using tone gives you a better means of 'modelling' the figure to express the mass and volume that is often one of the most exciting aspects of the subject. Employing contrasts of tone that recreate the effects of light can also create a strong emotional impact. Some artists have taken the study of light, and the dramatic or mysterious impressions it can create, as the central theme of their work.

Tonal media

Tones can be built up with any drawing or painting medium, even a pen, but in this case you will have to use hatching and crosshatching methods, which are very slow, especially if you are working on a large scale. The best medium to start with is charcoal, which can be smudged with a finger or used on its side to create

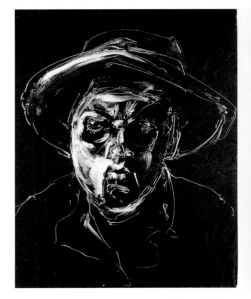

Monoprint *This monoprint was sketched from a black-and-white photograph in which the contrast between light and dark tone was very pronounced.*

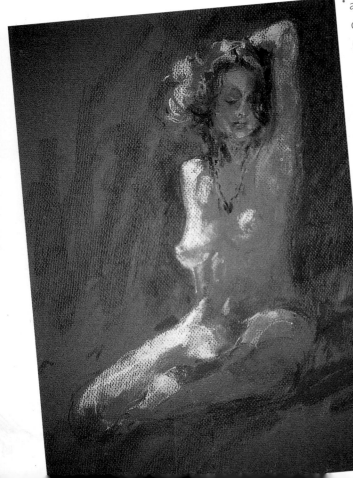

areas of tone very quickly. You can also easily modify or erase charcoal. Lighten an overly-dark area by rubbing over it with tissue or rag, and remove whole areas with a putty rubber so that you can work dark to light as well as light to dark.

Other good media for tonal drawing are Conté crayon (harder to erase than charcoal) and ink or watercolour, which can be diluted to the required strength and applied with a brush. Wash drawings, or line combined with wash, have a long tradition in figure drawing, and can be extremely effective. The technique is not ideal for beginners, as mistakes cannot be corrected, but it can be a valuable step on the learning curve, as it forces you to make decisions.

The importance of lighting

You will need to consider the lighting when you are making tonal drawings, as this will have a great impact on your work. A figure lit directly from the front, or by

Mood indigo *The artist has created dramatic contrast in this colourful pastel study, with the model's skin tones defined in bright highlights and offset by the rich indigo of the toned paper.*

an overhead fluorescent light, will appear very flat, with few tonal gradations, while side-lighting creates strong contrasts of tone. If you attend a life-drawing class, there may be moveable lights that can be placed to one side of the figure for exercises in tonal drawing, or you could set up a similar type of lighting at home, either by using an adjustable lamp or by placing your model so that they are lit from the side by a window.

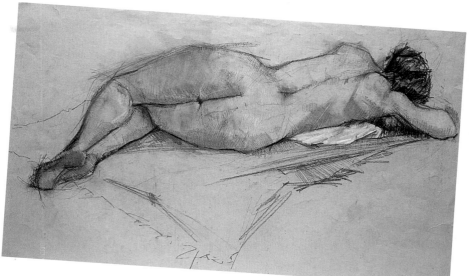

View from the back *A reclining back view provides plenty of tonal possibilities as the bones and muscular structure present gentle undulating curves and slopes not unlike those of a landscape scene.*

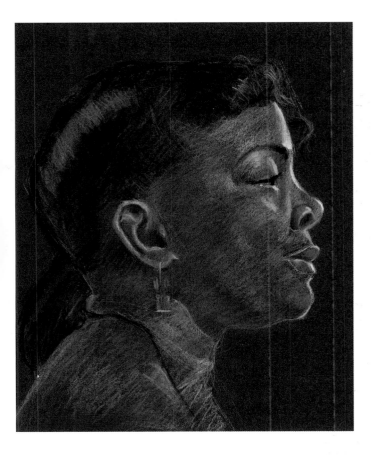

Light and tone in pastel *The artist has used the subtlest of highlights and gradations of colour to suggest light, tone and three-dimensional form in this profile study.*

Dramatic effects

One of the lighting effects many artists have exploited both for figures and still lifes is *contre-jour*, or 'against the light'. If you pose a figure against a window, the body will be semi-silhouetted, with the dark areas in the middle and the main light curving around the outside of the forms. The depth of tone will depend on the strength of the light; if bright sunlight is coming in from the window, the tones on the figure will be very dark, while a low light level will reduce the contrasts.

Candlelight also creates exciting and unusual effects, and you can try these out on yourself in front of a mirror, illuminating your face from different angles. This is a useful exercise to discover how many different effects you can create with directional lighting.

EXERCISE **6**

Reclining nude

by Lucy Watson

When making tonal studies, it is easier to work on tinted paper, as this provides the middle tone, allowing you to draw in the highlights rather than reserving them as white paper. The artist is working on a mid-grey paper, and uses a sanguine (red-brown) Conté pencil and Conté crayon to render areas of shading, and a soft Naples Yellow pastel for the highlights. When setting up the pose, she deliberately kept the colour variation to a minimum, as this makes it easier to concentrate on the play of light. In a foreshortened pose such as this, the work of the artist can be simplified by breaking the body up into basic shapes as shown.

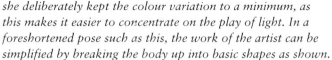

Practice points

- **DRAWING WITH THREE TONES**
- **MAKING AN ACCURATE OUTLINE DRAWING**
- **CHECKING PROPORTIONS**

STAGE 1

DRAWING THE OUTLINE

■ Before starting the drawing, take some time to study the perspective effect. The head is nearest to the viewer with the body receding, and the legs move in two directions, towards and away from the viewer. Measuring with your pencil (see page 11) will help you plot the basic proportions and angles. Starting from the head and gradually working downwards towards the feet, lightly sketch in the outline with the sanguine Conté pencil, checking one shape against another as shown left.

The hip is visible at about the halfway point on the upper arm. Because of the foreshortening, little else of the torso is seen except for the upwards curve of the stomach behind the arm.

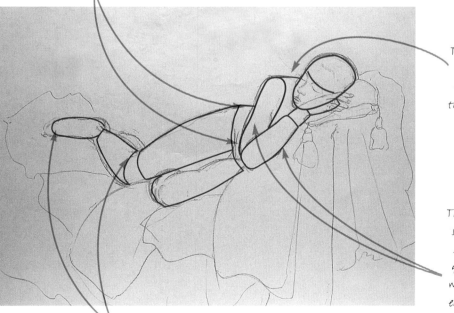

To start, draw the head as a smooth oval, lightly sketching in the features when you are sure of the angle. Note that the edge of the shoulder begins approximately at the model's eye level.

The right arm drops vertically at a slight angle, then the forearm rises sharply upwards to meet the head again. The wrist begins almost level with the chin, while the forefinger ends at the level of the eyebrow.

The legs are foreshortened, with the lower leg moving away, and the right foot in full view. Only the toes of the left foot are seen, resting against the curve of the right calf.

STAGE 2

STARTING THE SHADING

■ Now look carefully at the model and try to identify the main areas of tone. It is helpful to half-close your eyes, which cuts out some of the detail and thus simplifies the tonal pattern. The first two stages of the shading are done with the sanguine Conté pencil shown left.

When the outline of your model is complete, you can use your pencil to measure the proportions to ensure that they are correct (see page 11). In this study, the right foot is approximately the width of the head.

Make the shading darker at the back of the head to give the impression of the form turning away from the light into shadow.

Concentrate on the darker areas first, working light shading over the outlines, following the direction of the curves.

Notice how adding tone to the left leg begins to explain the forms, which looked strange when seen in outline alone.

STAGE 3
TIGHTENING UP

■ Now that you have begun the shading, stand back from your work to assess it. You may see that you need to make some adjustments to the main outline, but remember that the pose may change slightly as the model relaxes into it, so don't try to keep up with any slight 'slippages' or the drawing will become confused.

When you are sure all the proportions are correct, begin to build up some detail on the face and head.

Take care with the modelling of the shoulder and collarbone. The gradations of tone are sharper here than on the softer forms of thighs and calves.

Notice the shadow along the forearm made by the bone, and the dark shadow at the wrist, where the flat plane of the hand bends over slightly.

STAGE 4
BLOCKING IN BROAD AREAS

■ Now that everything is in place, you can work rather more broadly, using the sanguine Conté crayon instead of the pencil. It is tempting to dwell on details such as facial features and hands, but at this stage the emphasis is on working the tones in a continual flow over the body so that it is seen as a cohesive whole.

Start to define the cushions and drapes so that the model appears to be supported rather than floating in space.

Add broad areas of tone, taking care to work lightly, as more tone and highlight will be added in the next stages.

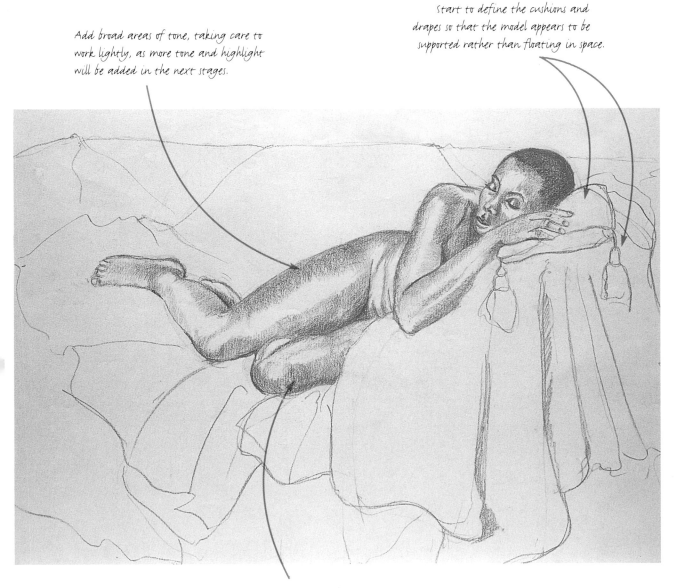

Too strong an outline has a tendency to flatten form, giving a cut-out feel to the body, so use the Conté crayon to blur the outlines and blend them into the areas of tone.

STAGE 5
SHARPENING UP

■ Now you can build up the modelling more solidly, darkening shadows where necessary and working on the highlight areas with the Naples Yellow pastel. Don't overdo the highlights, as it is important to allow areas of the neutral-coloured paper to show through, forming the midtone.

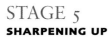

Both Conté crayon and pastel sticks can be used on their side to lay light drifts of colour over the paper.

Work over the finer details with the Conté pencil, sharpening up areas around the eyes, nose and mouth as well as on the fingers and the toes.

The addition of very gentle highlights over the entire body brings the figure to life by giving a strong three-dimensional sense of form.

STAGE 6
FINAL ADJUSTMENTS

■ At this stage the model is asked to take a break to allow the artist to assess the drawing and decide whether any further adjustments are needed. It is important to know when to stop, or the drawing can become overworked.

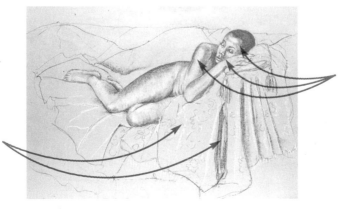

Add shadows and highlights to the sofa and cushions, with a light suggestion of pattern on the drapery to add interest and set off the head and shoulders.

Deepen the darkest shadows and accentuate just the brightest points of highlight sparingly, on the forehead, eyelids, tip of the nose and shoulder.

EXERCISE 7

Draped figure
by Clarissa Koch

The height and direction from which light reaches a subject can have a profound influence on its appearance, transforming it from a seemingly flat shape to its true rounded or angular form. Strong directional lighting is cast from the right onto this model, producing gradations of light that give important clues to her body's three-dimensional form and emphasising the folds and creases of the rich fabric draped over and around her. The artist chose a smooth, mid-brown paper for the sketch, its texture and colour providing her with the midtone of the model's skin. Dark shadows and highlights were then applied with the sharpened ends of a graphite pencil and white Conté pencil respectively.

> **Practice points**
> - IDENTIFYING TONES
> - BUILDING UP FORM
> - WORKING ON COLOURED PAPER

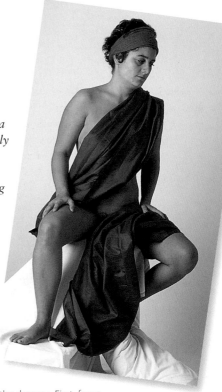

STAGE 1
DRAWING THE OUTLINE

■ As the model will require breaks from the pose, this piece is worked over in carefully planned stages in order to minimise any disturbance to the complex folds of the drapery. First, focus your attention on the figure, making only a brief outline of the drapery until the model has taken her first break.

Lightly draw in the outline of the figure with the graphite pencil, paying attention to the rhythm that the model and drapery create together, but leave the treatment of drapery until a later stage when the model has taken a break.

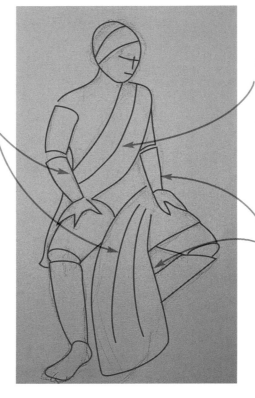

The drapery is arranged to sweep around the body so bringing movement to the pose as well as supporting the sitting position by dropping to the floor.

The outline is very light to allow any alterations in figure proportion and positioning to be amended at this early stage and avoiding the need to erase any mistakes.

TIP
Before you sketch your outline, try to reduce the figure and drapery to a set of basic shapes as shown.

STAGE 2
INDICATING SHADOW

■ When you are satisfied with the outlines and positions of the body and drapery, you can begin to define the shadow areas, especially on the nape of the neck, the right inner thigh and the stomach. The areas of shadow are drawn in as shapes on the figure and drapery, and filled in very gradually using the soft hatching lines of the graphite pencil.

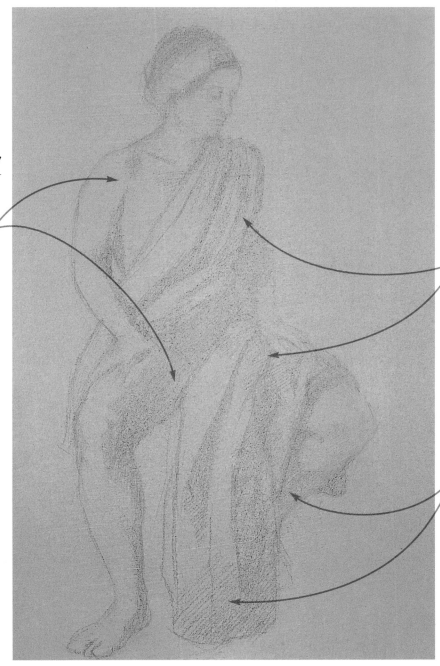

space the hatching lines further apart for the lighter tones and use heavier pressure and closer spacing for the darks.

Use loose outlines to describe the main folds and tonal areas of the drapery, then draw in the shapes of the shadows, blocking them in with light hatching strokes. Once you have noted the detailed "structural information" in the drapery, you can allow the model to take a break if necessary.

Gradually work up the dark tones by continuing to crosshatch over the figure and drapery as a whole.

STAGE 3
BUILDING UP HIGHLIGHTS

■ Add the brightest highlights on the drapery and then the figure, using the white Conté pencil. The highlights emphasise the form and three-dimensional mass of the figure on the flat paper surface by showing up the skeletal protrusions of the collar bone and fingers, and the outlines of the subject that are closest to the light. Screw up your eyes and look at the figure to help you define the lightest and darkest areas of the drawing.

TIP
If possible, take a black-and-white photograph of your model in the same pose, and with the same strength and direction of lighting, to help you isolate the tonal areas more clearly before you start to draw.

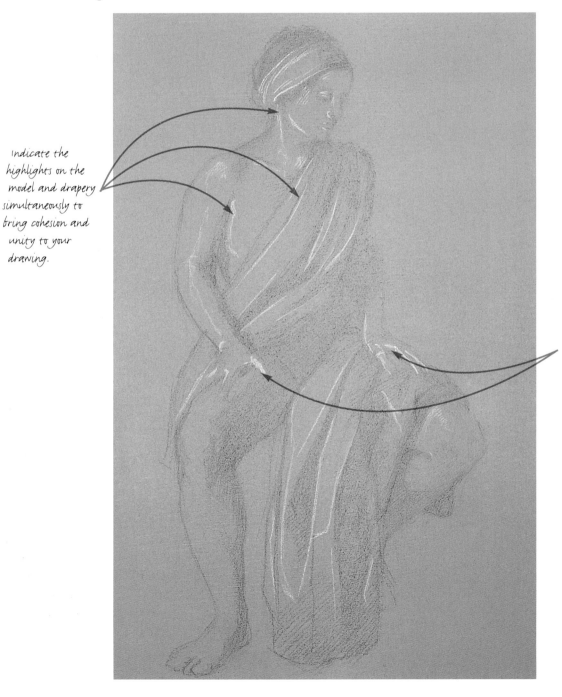

Indicate the highlights on the model and drapery simultaneously to bring cohesion and unity to your drawing.

The barest hint of strong white on the outline of the hands brings them forwards in space and marks them out from the legs and drapery.

STAGE 4
FINISHING TOUCHES

■ Work over the whole pose now, adding in the softer highlights by crosshatching with the white Conté pencil. This will enliven the sketch and push the figure forwards out of the shadows. To finish off, look for the darkest accents in the folds of the drapery and intensify the lines where the the shadow shapes turn away from the light. These are the lines of greatest darkness in the shadow areas and emphasising them with fine crosshatching produces an added sense of volume.

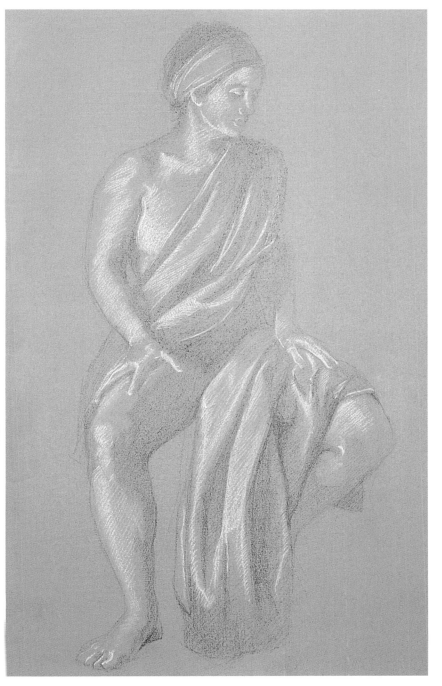

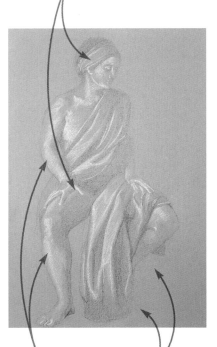

Finish off the drawing by adding accents of light and dark on the band in the hair and the outline of the hands.

Add very gentle hatching to the right side of the figure, building up the lightest areas by crosshatching and adding a little more pressure with the white Conté pencil.

Lightly indicate the surround of the model; some vertical lines indicate the chair and 'fasten' the pose to the ground.

Using colour

If you have never before worked in colour, you may be daunted by the vast range of available media. If you are a beginner you will want to start with a fairly 'forgiving' medium that allows you to make corrections and doesn't demand too much in terms of technique. Watercolour, for example, takes time to master, and trying it out for the first time for an ambitious nude study could lead to frustration.

Soft pastels and oil pastels

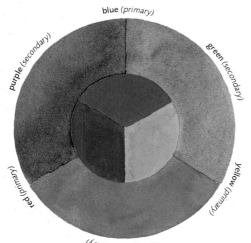

Some of the greatest of all figure studies were made in pastel by Edgar Degas in the nineteenth century, and soft (or chalk) pastel remains a popular medium. One of its major advantages is that it is so immediate; you don't have to draw an outline and then 'fill it in', because the drawing and the painting are a joint process. You can cover the paper very quickly if you use the side of a pastel stick, or draw a line and smudge it with your finger, and you can make corrections or amendments simply by working over an area with more colour. Co ours are mixed on the paper surface in the same way. For example, you can make green by laying yellow over blue, so you don't need a vast range of colours from the start.

Another type of pastel is the oil-based version, which is also worth trying. The colours don't smudge, as soft pastels do, but they can be blended together. Very effective tints can be made by working lighter colour into darker. But whether you use chalk or oil pastel, limiting the number of colours you blend will help keep them fresh and vibrant.

Coloured pencils

Pastels and oil pastels are best for broad effects worked on a relatively large scale, as the sticks are too large and clumsy for very precise work. For small-scale drawings, coloured pencils could be a better choice, especially for sketchbook studies made on the spot, as they are light and portable, and don't involve getting your fingers dirty. They are best suited to a linear approach, though you can build up solid areas of colour and depth of tone by

Simple colour wheel *The colour wheel shows the three primary colours – red, blue and yellow. Secondary colours are made by mixing any two primary colours together. Complementary colours, such as red and green, or orange and blue, fall directly opposite one another on the colour wheel. These create very strong contrasts which can be used to enliven a painting. Colours can also be described as warm or cool. A colour is said to be warm if it has a bias towards red, orange or yellow, and said to be cool if it has a bias towards green, blue or purple.*

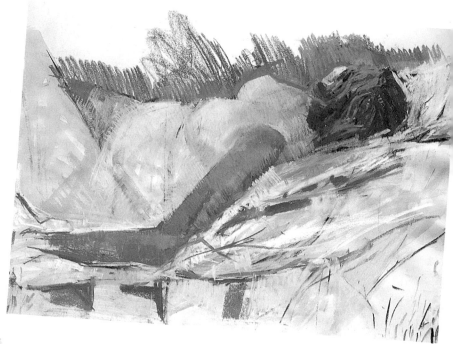

Choice of palette *The artist used a limited palette of colours for this sketch, but created vibrant contrasts between the range of blues and greys on the one hand, and the many tints and shades of yellow and orange on the other.*

hatching and crosshatching. This is a slow process, but if time is not a factor – perhaps if you are working from a photograph – you may find it a rewarding technique, and you can create lovely effects by laying colours over one another.

Painting media

Watercolours are also very good for outdoor sketches, especially when combined with a linear medium such as pen or pencil. You don't have to be an experienced watercolourist to work in this way, as the line will provide the basic structure of the drawing, with the colour providing an extra element.

Both oil paints and acrylics are best used in a studio setting, as they are messy, and involve carrying a lot of equipment. Oils are not easy to handle unless you have some experience, but acrylics are excellent for figure work, whether full paintings or short poses. They have no smell and dry very fast, so you won't have wet canvases or boards to carry home. The greatest virtue of acrylics from the amateur point of view is that you can make as many changes and corrections as you like simply by painting over them.

Skin tones *The artist has used the complementary colours of yellow and purple to describe the flesh tones in this study with startling effects.*

Colour media *Watercolour paints are available in several forms including tubes (far left) and half-pans (left, top). Like tubes of watercolour paint, pans can be found in boxed sets (below) or bought separately. Coloured inks (left, bottom) can be used with watercolours for interesting effects.*

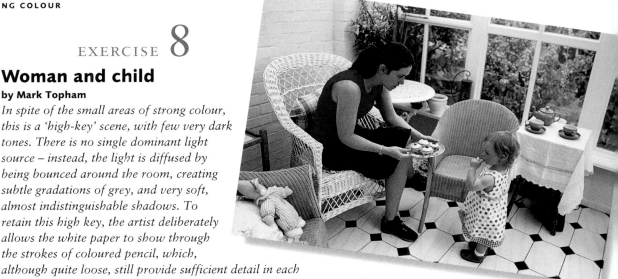

EXERCISE 8

Woman and child

by Mark Topham

In spite of the small areas of strong colour, this is a 'high-key' scene, with few very dark tones. There is no single dominant light source – instead, the light is diffused by being bounced around the room, creating subtle gradations of grey, and very soft, almost indistinguishable shadows. To retain this high key, the artist deliberately allows the white paper to show through the strokes of coloured pencil, which, although quite loose, still provide sufficient detail in each area. Another important aspect of the subject is the strong narrative theme, with all the woman's attention focused on the small child. The windows and floor provide a good balance of geometric structures against the gentler curves of the chairs and the figure of the woman.

STAGE 1
THE UNDERDRAWING

■ Draw the shapes lightly with graphite pencil, carefully checking the proportions. Graphite is easier to erase than coloured pencil, so you can correct any errors as you work. Concentrate on the main shapes, and when you are satisfied, go over the pencil lines with a brown coloured pencil.

> **Practice points**
> - DRAWING WITH COLOURED PENCILS
> - USING A LIGHT TONAL KEY
> - CREATING ATMOSPHERE

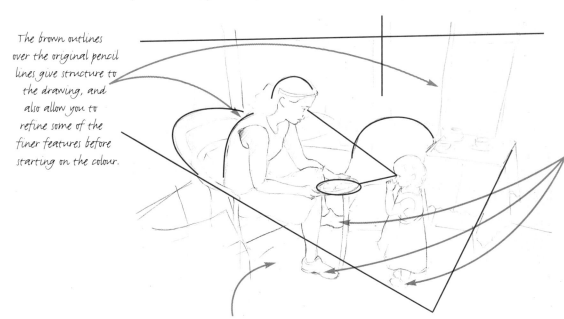

The brown outlines over the original pencil lines give structure to the drawing, and also allow you to refine some of the finer features before starting on the colour.

Make sure that the proportions and placing of the limbs are correct. Notice how the woman's feet show the way she is sitting, and the child's feet are slightly further towards the front of the picture plane.

The interlocking shapes of the floor tiles are a feature of the busy composition, but leave these until later, or you may become mired in detail.

STAGE 2
BLOCKING IN THE MAIN SHAPES

■ Start by lightly sketching in the main shapes, using loose strokes for the larger areas, such as the windows and walls, and smaller, finer strokes for the figures to give the first impression of form. But don't take any stage of the drawing too far towards completion, because coloured-pencil drawing involves building up gradually by laying colours one over the other.

Vary the tones of the short strokes slightly to hint at the form, but don't attempt too much modelling at this stage.

Make long, free strokes of blue and brown, which will form a base on which to build more colours.

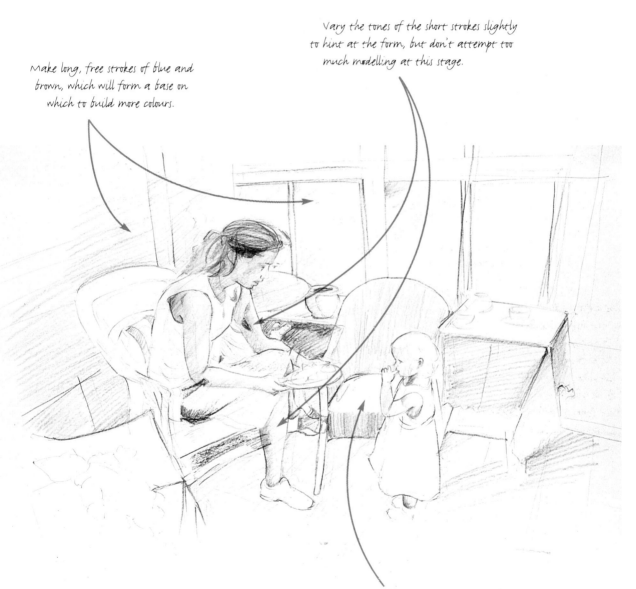

Let the pencil strokes follow the direction of the chair to suggest both its form and its texture.

STAGE 3
ESTABLISHING THE COLOURS

■ The woman's clothes represent the brightest colour and darkest tone in the picture, so put these in place before you decide on the other tones and colours. Although the skirt appears as a very solid near-black in the photograph, avoid making it too dark, as this would destroy the overall lightness and feeling of delicacy.

A blunt pencil is best when making broad strokes for the background, but always keep the pencil well sharpened for detail.

Colour in the red top with a rose-coloured pencil, using it fairly densely but still leaving some white paper showing through.

Draw in the woman's hair with directional strokes of dark brown over a red-brown, and when this overall tone is fully established, put light ochre on the child's hair and some light strokes of ochre and red on the skin areas.

Work over the skin areas with a yellow ochre and red, adding brown in the darker shaded areas such as the back of the shoulder and under the chin.

Use strokes of dark blue that follow the direction of the folds, making them lighter and further apart in the highlight areas. You will be building up the colours by layering at a later stage.

STAGE 4

PUTTING IT INTO CONTEXT

■ Once the figures have been drawn in and the main colours are in place, you can begin to work on the surroundings. Think about the tonal values first and decide where you want a dark tone to balance a light one or vice versa. Try to work as freely as you can; if the background appears too laboured or over-detailed, it will detract from the primary subject of the picture.

Make directional lines of brown for the wall behind the chair, with more closely hatched lines of blue shadow at the bottom, taking care not to go over the back and side of the chair, which must be reserved as a lighter colour.

Build up the form of the pot with shading on the left side. This is an important element in the composition, as it provides a link between the two figures.

Give form and structure to the chairs by adding detail and descriptive lines, and build up the tonal contrasts, using dark green for the empty chair to make the child's head stand out.

STAGE 5
LAYERING COLOURS

■ At this stage in the drawing, it is helpful to take a break and then look at the drawing with a fresh eye so that you can assess how much more needs to be done. The artist decides to continue building up the colours all over the picture by layering, but he still works fairly loosely to enable him to add a final layer if needed. He also brings in further details, such as the checked cushion, the doll in the left foreground, which enhances the narrative element and the pattern of floor tiles.

TIP
Remember that you cannot go on layering colour indefinitely. Once the tooth of the paper becomes clogged, the colours will slide off, so always leave a little paper showing.

Layer more red on the woman's top, and then add some sketchy greenery and flowers behind her. The yellow provides a pleasing colour accent to complement the red.

The foliage makes a perfect backdrop for the figure, and brings in a dark tone to balance that of the skirt. Begin to suggest this with loose strokes of dark green.

Keep the lines simple so that this foreground feature does not steal attention from the figures.

The floor tiles give a spatial element to the drawing, and also add interest to this large area. Take care with the perspective, but don't treat the tiles in too much detail.

STAGE 6
THE FOCAL POINT

■ Sometimes the focal point of a picture is decided by the strength of colour or tonal contrast, but in this case the child is the focal point because she is the central player in the 'story', expressing so much by standing with a finger in her mouth. The artist decides to build up the figure very carefully so that he does not lose the feeling of delicate fragility.

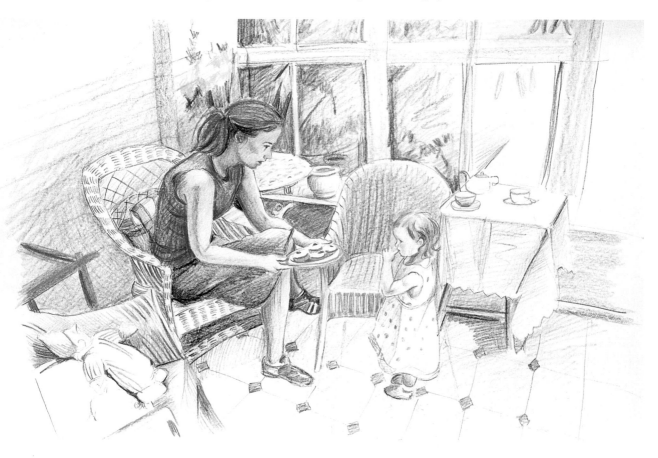

To suggest the fineness of the hair and softness of the flesh, make much of the hair very pale, almost skin colour, and draw the face mostly in outline, using very well-sharpened pencils.

Complete the foliage, working loosely to give the slightly out-of-focus impression that will make it go back in space.

The cakes are vital to the narrative and make a visual link between the woman and child, but they can be drawn very simply with some dark and light brown.

THE FUNDAMENTALS

The clothed figure

Drawing the nude is an excellent way of getting to understand the forms and proportions of the human body and how it moves, but in real life people are seldom naked, so in order to make your drawings convincing you will need to pay as much attention to the clothes as to the body beneath them.

Character and atmosphere

The clothes people choose to wear tell us something about their characters, their interests, and sometimes their occupations. If you were making a portrait study, you would want the sitter to wear clothes he or she would normally wear, rather than to dress up in their finest clothes, which would deprive the work of important clues about the person. Through the centuries, artists have drawn and painted people wearing clothes that mark their occupations or interests, two well-known examples being Rembrandt's self-portrait at his easel and Van Gogh's The Postman Roulin. You can bring this kind of narrative element into your outdoor sketches in a similar way, while also creating a sense of atmosphere. For example, light clothing tells the viewer it is summer, and perhaps that the people are happily relaxing, while a figure dressed in a heavy coat and scarf is obviously battling against the elements, and may be far from happy.

Classical studies *You can conjure up the elegant contours of an ancient Greek statue by draping no more than a sheet of fabric over your model.*

Looking for clues

In a way, it is more difficult to draw a clothed figure than a nude; because so much is covered, it is easy to misunderstand the proportions. If you are making a long study rather than a quick sketch, try to visualise the body beneath the clothes, and even sketch it in lightly if you find this helpful. Then look for any clues that may help you to identify the position of the body and limbs, such as the angle at which the head and neck emerges from a collar, the position of the hands and feet and so on. This is especially important in the case of loose or bulky clothing, which tends to disguise the shapes and forms beneath it. But even so, you will notice that clothes tend to hang from some parts of the body, such as the shoulders and hips, and cling to others, such as breasts or an elbow when the arm is bent.

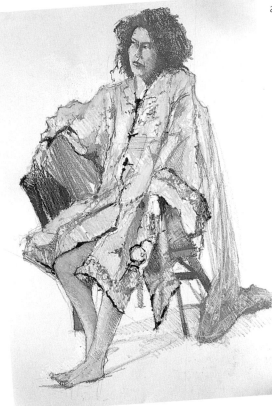

Highlights on silk *This exotic-looking silky yellow robe hangs loosely from the model's body and reflects large panels of light.*

Dressing up *You may want to ask your model to dress up to add a theatrical touch to your sketch. Simple costumes can be made using scarves, shawls and colourful jewellery.*

Helpful clothing details

Some clothes and accessories are actually helpful as they provide contour lines that give you a useful way of describing form. The lines of a horizontally striped sweater will follow around the forms of the breasts, while a plain sweater would provide only tonal gradations. A watch, a bracelet or the bottom of a sleeve defines the shape of the wrist, which can be hard to draw, while spectacles provide a set of straight lines and curves that give you a precise indication of the tilt of the head.

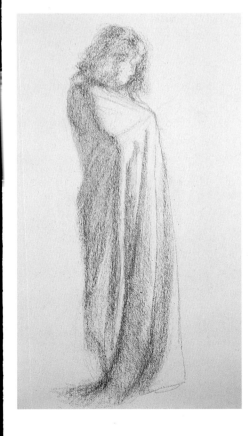

How much detail

The amount of clothing detail you include depends both on the subject and on how much time you have. The clothes may be important in a portrait, but don't let them steal the show. The face, and perhaps the hands, should be the centre of interest. In outdoor sketches, concentrate on the main lines of the body and clothing and if you want to work sketches up to a more finished painting, take a photograph or two so that you have sufficient information. When you are working fast, it is easy to leave out visual information that later turns out to be important.

Light and tone *Monochrome sketches are excellent ways of focusing attention on the folds and creases of an item of clothing and the way in which the fabric follows the contours of the model's body.*

EXERCISE *9*

Woman in a yellow robe
by Barry Freeman

For this colour study, the model is dressed in an exotic brilliant-yellow robe that perfectly complements her olive complexion. Although neither you nor your chosen subject are likely to have quite such fine raiment on hand, it is worth looking through your wardrobes, as you may find a particular colour or texture that fires your imagination. The artist is using oil pastels, which are produced in rich, bright hues as well as ranges of useful neutral colours. They are ideal as a sketching medium, as they don't smudge, and can be used for both drawing and painting. Although the figure is clothed in a loose robe, it is important to imagine the form of the body beneath. Just a few simple lines drawn at the beginning will provide a structure on which to 'hang' the garments.

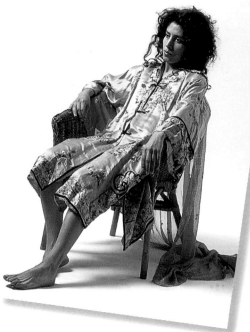

> **Practice points**
> - MAKING A CAREFUL DRAWING
> - ACHIEVING BRILLIANT COLOURS
> - WORKING IN OIL PASTEL

STAGE 1
FIRST STEPS

■ Start by sketching the figure very lightly with a soft pencil – 3B or 4B. Be prepared to spend some time on the drawing, as seated figures can be tricky, and it will be difficult to make major corrections later. When you are confident that the shapes and proportions are correct, begin to apply colour, starting with the robe, and leaving white highlights. Put a touch of red on the lips to echo the red drapery to be applied next.

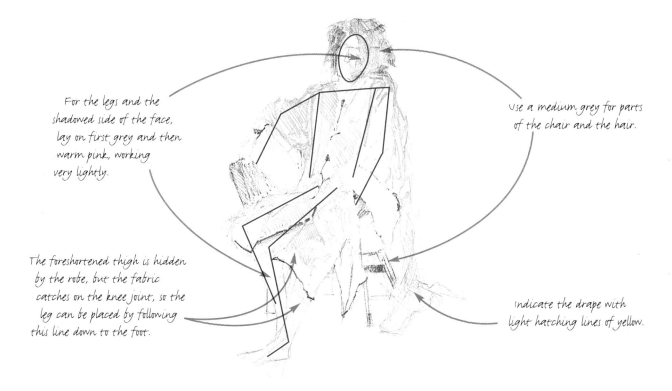

For the legs and the shadowed side of the face, lay on first grey and then warm pink, working very lightly.

Use a medium grey for parts of the chair and the hair.

The foreshortened thigh is hidden by the robe, but the fabric catches on the knee joint, so the leg can be placed by following this line down to the foot.

Indicate the drape with light hatching lines of yellow.

STAGE 2
ADDING COLOUR AND DRAWING

■ Now that the main shapes are established, you can begin to bring in new colours, suggest the darker tones, and add crawn detail on the robe.

Pastel colours are mixed on the paper surface by applying one over another. Always work lightly to begin with, as too many layers of colour will clog the paper.

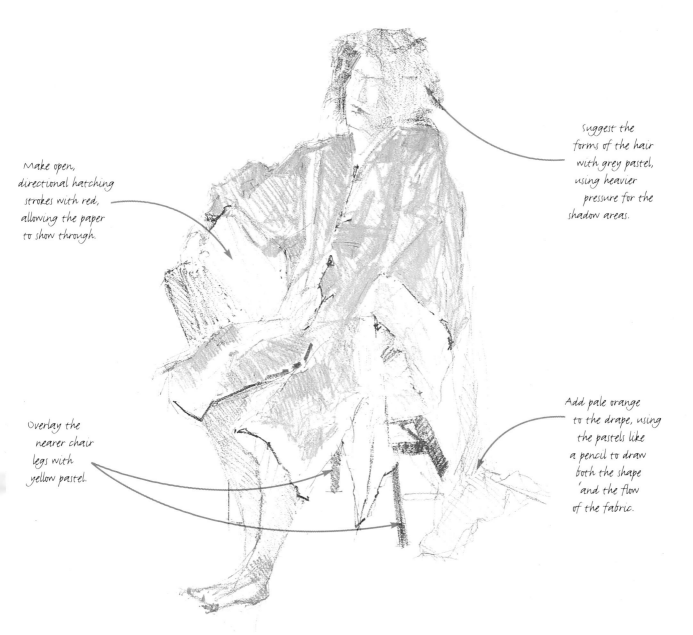

Make open, directional hatching strokes with red, allowing the paper to show through.

suggest the forms of the hair with grey pastel, using heavier pressure for the shadow areas.

Overlay the nearer chair legs with yellow pastel.

Add pale orange to the drape, using the pastels like a pencil to draw both the shape and the flow of the fabric.

STAGE 3
BUILDING UP

■ Continue to build up the colours, especially the darks, by increasing the pressure on the pastel sticks, but leave white paper showing in the lighter and brighter areas.

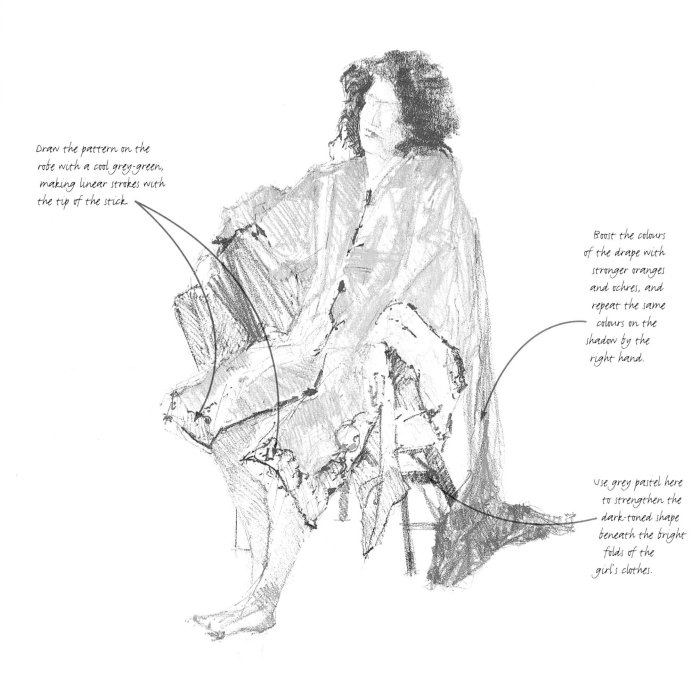

Draw the pattern on the robe with a cool grey-green, making linear strokes with the tip of the stick.

Boost the colours of the drape with stronger oranges and ochres, and repeat the same colours on the shadow by the right hand.

Use grey pastel here to strengthen the dark-toned shape beneath the bright folds of the girl's clothes.

STAGE 4
FACIAL DETAIL

■ Once you have laid down the first colours, turn your attention to the finer details of the face. The face is almost always the focal point in figure work so work over this part of the body carefully as it will attract the greatest attention.

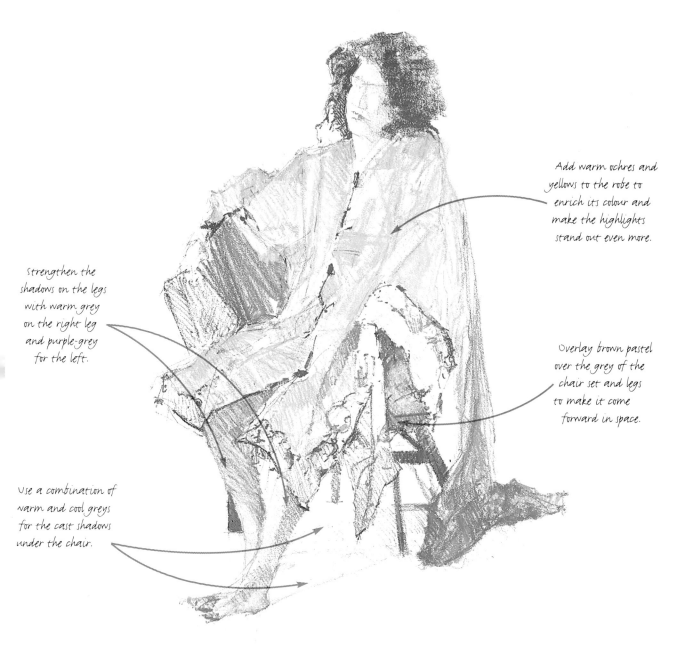

Add warm ochres and yellows to the robe to enrich its colour and make the highlights stand out even more.

strengthen the shadows on the legs with warm grey on the right leg and purple-grey for the left.

Overlay brown pastel over the grey of the chair set and legs to make it come forward in space.

Use a combination of warm and cool greys for the cast shadows under the chair.

STAGE 5
DEFINITION AND DETAIL

■ Continue to strengthen the colours and tones, still using the pastel as a pencil except on the legs, where softer blends of colour are needed. This mainly linear treatment retains the sketchy quality that gives a sense of life and movement. At the same time, bring in touches of detail, especially on the robe.

The eyes are painted to look slightly upward and away from the viewer lending the pose a relaxed, meditative feel.

Use grey pastel fairly heavily here to produce a dark-toned shape. This helps the red and yellow to stand out and provides a balance for the dark hair.

Areas of deep shadow are deepened on the neck helping to emphasise the jaw line in contrast to the bright play of light over the face.

STAGE 6
FINAL TOUCHES

■ It is important to know when to stop, because overworking will destroy the liveliness of the sketch. Also, the medium itself can lose its freshness if too many layers are added. This artist decides to soften some shadows, to add more colour to others, and to bring in slightly more detail and definition on the robe and head.

The artist works warm dark brown over the original grey, which he found to be too similar to the hair.

Soften the shadow side of the face with pale orange, and sketch purple-grey and pale brown over the front of the hair.

Soften the leg shadow with pale, cool grey, using the pastel on its side to lay a light veil of colour.

Work a warm blue over the browns in the shadow areas of the chair, and add a little of the same colour to the shadow beneath the drape. At the same time, stengthen the drape itself with dark orange.

Focus on Figures

Once you have mastered the fundamentals, you may wish to concentrate on the more detailed and advanced aspects of figure drawing. Simple step-by-step exercises show how to perfect those details that will set your sketch apart.

FOCUS ON FIGURES

The head

Beginners sometimes find the head difficult to draw, but this is usually because there is a natural tendency to focus on the features rather than seeing the overall shape of the head. Never start a figure drawing, or even a portrait study, with eyes, noses, or mouths fascinating though these are. Establish the shape and position of the head first, and take careful note of its angle on the neck, as this is vital in establishing its position.

Seeing the main shapes

The head, seen from the front, is shaped very much like an egg, which pivots on the cylinder shape of the neck, so the best way to start is to mark in this shape, taking note of what happens when the head is bent down. In this case the 'egg' will be seen in perspective, so the shape will be more round than oval. Seen in profile, the head shape can be seen as one egg shape superimposed on another, as the back of the skull juts out, making a flowing curve from the crown of the head down to the back of the neck. Although there are individual variations in head shapes and sizes, they are not as great as the differences between the facial features, so these basic head shapes are always a good starting point.

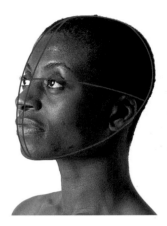

Facial proportions *Seen from any angle, the proportions and structure of the head remain fairly consistent, so getting these right is an important starting point when beginning to sketch.*

The proportions of the head

Another common mistake is to make the features too large in relation to the head shape. The facial features in fact occupy only about half of the whole head, with the top of the eyes roughly marking the halfway point. When you have established the shape and position of the head, and are ready to start on the features, it is helpful to mark in this crucial point with a light line; if the head is tilted, curve this line around the basic egg shape. This will also give you a guide for the ears, as the tops of the ears line up with the tops of the eyes, and the bottom of the nose with the bottom of the ears. These are standard proportions, and do, of course, vary from person to person, but it is useful to bear them in mind, as it helps you to analyse the ways in which the person you are drawing differs from them.

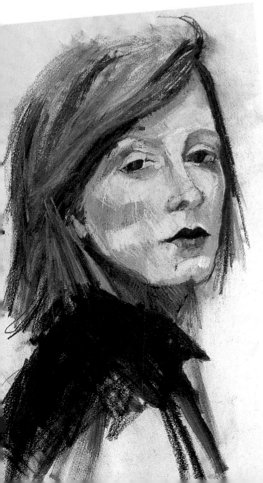

Colouring the character *The vigour and darkness of the marks that describe the model's hair and blouse are a striking contrast to the soft colours and subdued expression of her face.*

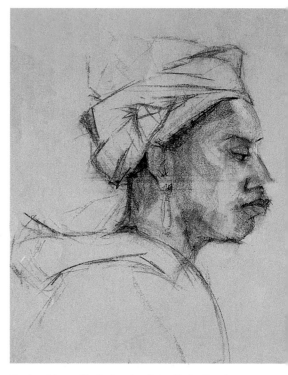

Tone and watercolour
Watercolour is not an easy medium to rectify, so the artist first made a pencil sketch to familiarise himself with the main outline and tonal areas before adding colour.

Facial features

Like body shapes, facial details display a wide range of variety across the human spectrum, depending on age, gender and race. When drawing faces, you need to pay particular attention to the dimensions of the features and the spaces between them. Babies, for example, tend to have high rounded foreheads and small features that appear confined to the centre of the face. Generally speaking, adult

The head in profile *Seeing a head in profile significantly accentuates its underlying structure. The height of the forehead, the overhang of the eyebrows, the setting of the eyes, the slope of the nose and the protrusion of the lips and chin are all seen much more clearly from this aspect.*

males have gaunter features than adult females, while female mouths are usually softer and fuller than those of males, particularly in youth. Age affects muscle tone, changing the contours of the lips, the brightness of the eyes and the fine lines around them, as well as the prominence or otherwise of bone structure.

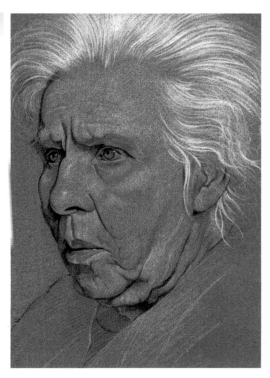

Mature subject *Using just a white chalk stick and a Conté pencil the artist has created this imposing portrait of an older subject.*

Child's face *Compared to adults, children often have relatively large foreheads. They also tend to have small mouths in relation to their other features and there is an outward thrust to the cheeks, which is most easily viewed in profile, as here.*

EXERCISE 10

Head study

by Lucy Watson

This exercise concentrates on the study of the head. This, like the other extremities of the body, has been left until a late stage in the book for a good reason. Beginners often pay too much initial attention to the head, worrying over facial features before considering the body as a whole, with the result that the pose is often misunderstood and the sense of rhythm and movement lost. In most figure drawings, the best way to work is to draw the head as a simple shape in the first stages, concentrating on the features only when you are sure that the structure of the body is correct and you can see the relationship of one part to another.

Practice points
- DRAWING GUIDELINES
- PLACING THE FEATURES
- BUILDING UP FORM

STAGE 1
GUIDELINES

■ Using a brown coloured pencil, draw the basic egg shape for the head, and then mark in two curving guidelines bisecting it vertically and horizontally. These will help with the placing of the features and also prevent you from making the common mistake of drawing the eyes and mouth on a flat plane. The placing of the horizontal line will be dictated by the angle of viewing; in this case the head is seen at a gentle perspective angle, as it is viewed slightly from below, with the model looking upwards and to the right.

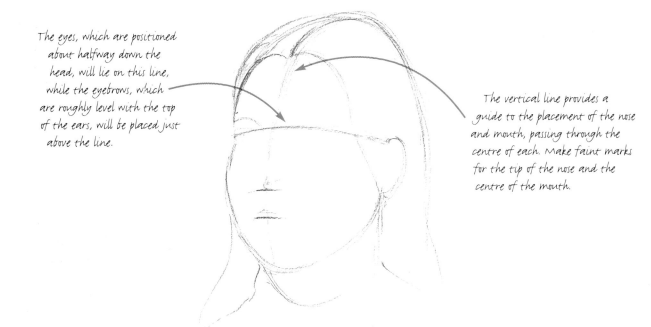

The eyes, which are positioned about halfway down the head, will lie on this line, while the eyebrows, which are roughly level with the top of the ears, will be placed just above the line.

The vertical line provides a guide to the placement of the nose and mouth, passing through the centre of each. Make faint marks for the tip of the nose and the centre of the mouth.

STAGE 2
DRAWING THE FACIAL FEATURES

■ Once you have roughly established the positions of the features, you can draw in the eyes, nose and mouth, always bearing the shape of the skull in mind, especially in relation to the eye sockets. Be prepared to make corrections to your work at this stage, as this is the time to amend any mistakes in positioning the features before taking the work further.

Draw a faint outline of the eye sockets as a guide to positioning the eyes, then draw the pupils, ensuring that both follow the same direction of focus.

Because the head is viewed slightly from below, the nostrils are just visible.

After making an outline of the mouth, adjust the chin, making it smaller or larger to fall in line with the other features.

STAGE 3
ADDING DEFINITION

■ Once the features are in place and have been checked and adjusted, you can begin to build up the drawing, adding more line and tone to define the head and face more strongly.

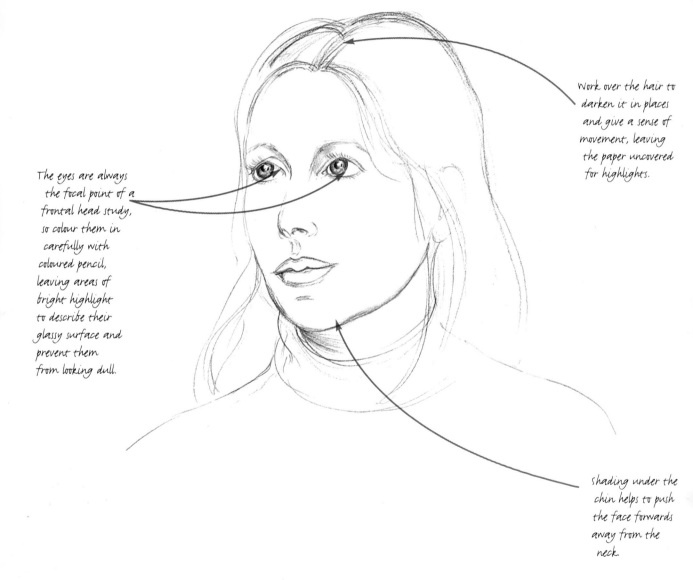

Work over the hair to darken it in places and give a sense of movement, leaving the paper uncovered for highlights.

The eyes are always the focal point of a frontal head study, so colour them in carefully with coloured pencil, leaving areas of bright highlight to describe their glassy surface and prevent them from looking dull.

Shading under the chin helps to push the face forwards away from the neck.

STAGE 4
BUILDING UP THE FORMS

■ To complete the study, tone can be added more liberally to emphasise the volume of the head and the forms of the individual features. Keep the direction of the light in mind. In this case it is coming from the right and slightly in front of the model. If you find it hard to identify the main areas of light and shade, use the old trick of half-closing your eyes.

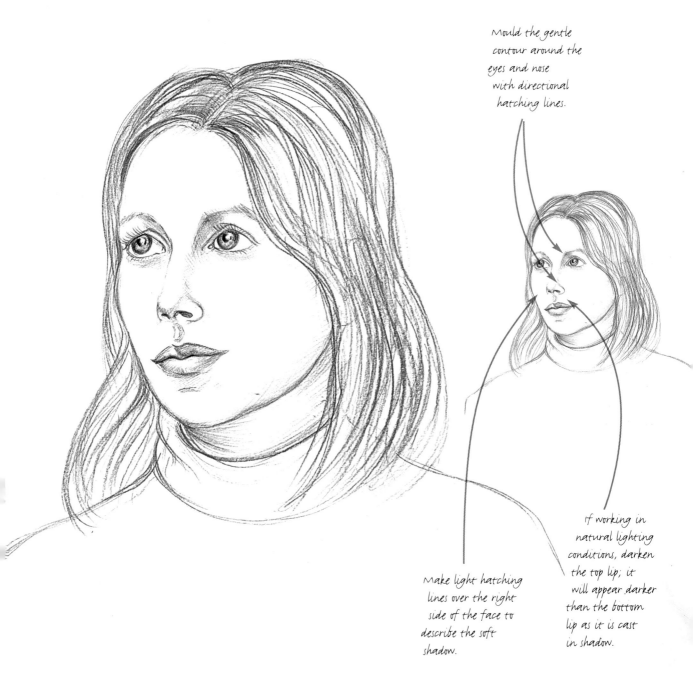

Mould the gentle contour around the eyes and nose with directional hatching lines.

Make light hatching lines over the right side of the face to describe the soft shadow.

If working in natural lighting conditions, darken the top lip; it will appear darker than the bottom lip as it is cast in shadow.

Details

The extremities, such as hands and feet, present the artist with more intricate shapes than the rest of the body so they are undeniably tricky to draw. However, like the head, they are easier if you can understand them as basic shapes and fortunately you can examine your own hands and feet at any time to analyse their structures.

Hands

Stretch your hand out in front of you, with the fingers pointing slightly downwards. You will see that the palm forms a flat, roughly square-shaped pad, while the four fingers form another plane comprising three jointed cylindrical shapes. The thumb pares off to the side and has just two joints. In almost all activities, whether the hand is slightly curled, clenched in a fist or even just pointing, all these joints come into play, often moving simultaneously. Hands are enormously expressive, and many portrait painters make a feature of them for this reason. You would want to do full justice to a hand supporting the model's head, for example, or a hand holding a glass, as otherwise the drawing would look incomplete. When you draw your model's hands, try to see them as a continuation of the body rather than attachments to the limbs. If they are dealt with as separate entities they often become overworked and look falsely 'attached' to the body.

Shadow and form
Strongly contrasting areas of darks and lights impart bulk and three-dimensional form to this gesturing hand.

Feet study
Try working from photographs showing feet in varying poses and from different viewpoints to familiarise yourself with their form and structure.

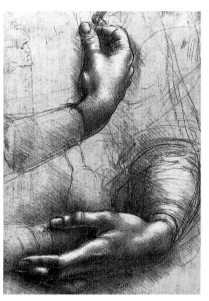

Old masters *As an exercise, copy drawings of hands, feet, ears, noses and so on from the works of great artists such as Leonardo da Vinci (above), in order to improve your skill and technique.*

Feet

Feet are less expressive than hands, as they are not such a sophisticated and versatile part of the body, but feet and ankles can be very important in the context of movement, helping to convey the tension of the body and limbs. And sometimes you will need to treat feet in detail simply to make sense of

them. A foot can present some unusual and challenging shapes because it will more often than not be foreshortened. Like the hand, however, the foot can be broken down into basic shapes. Think of the foot as a blunt wedge-like shape, which, with the big toe removed, has a small 'fan' of toes attached to it.

Facial features

Although there are enormous differences between people, the underlying structures are similar because they are dictated by the shape of the skull. The eyeball is a sphere, fitting into the bone socket, and although much of this is hidden, it is vital to remember that the eye is not a flat surface but a convex one, with the eyelids and brows in turn curving over it. Always draw both eyes together, especially in a three-quarter view, because the perspective must be consistent.

Mouths, like eyes, are often drawn flat. They are not, however, as the lips follow the shape of the jaw and teeth, and the sides of the mouth form two opposing planes with their high point at the centre of the top lip. The nose, which makes a link with the eyes and mouth, is basically a wedge shape, narrower at the top and widening out to a rounder shape, with the nostrils curving in to the sides of the cheeks.

Once you have grasped these basic shapes, you will have a structure on which you can build, and you can then begin to enjoy yourself by analysing and exploiting the individual characteristics of your chosen subjects.

Legs and feet
When drawing feet, think of them as a continuation of the legs and not as an appendage to the body.

The nose *It is often best to draw noses in relation to other facial features rather than in isolation.*

Ear shape *When drawing ears, use adjacent information – from the hair, jaw and neck – to help you define their basic shape and render their three-dimensional form.*

EXERCISE II

Hands and feet

by Lucy Watson

The extremities of the figure can often cause problems, but as with the figure as a whole, they are easier to understand if reduced to basic shapes and directional planes. Normally, hands and feet are part of the figure-drawing process, but it is worth making separate studies to familiarise yourself with the structures and movements. They make a rewarding drawing subject in themselves, especially hands, which are one of the most expressive parts of the body – over the centuries many artists have made beautiful and moving studies of hands. It is not necessary to attend a drawing class, as you can draw your own hands and feet as well as those of family members. To make your sketches look three dimensional, gradually build up areas of tone, using shading that follows the direction of the forms.

DRAWING HANDS

■ Start with simple outline drawings and gradually build up tone to show the forms. Draw the hands in as many different positions as possible. A frequent mistake is to overwork the detail of the hands and feet. This tendency can leave them looking lifeless or detached from the rest of the body. Use the trick of screwing up your eyes to help you define where the strongest areas of dark and light fall.

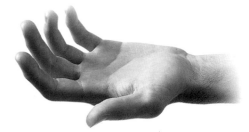

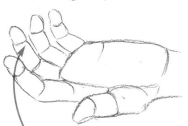

Using a sanguine Conté pencil, describe the fingers initially as a set of cylinders, set at angles to one another.

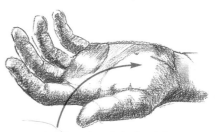

Areas of tone are defined by hatching while the darkest areas are worked on with crosshatching.

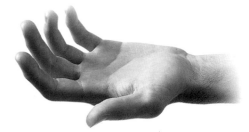

Make the palm of the hand form a flat, squarish disc shape. In this position, it curves quite sharply into the wrist at the bottom.

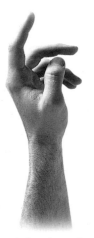

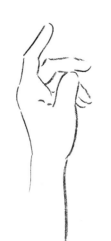

This charcoal drawing was traced from a photograph – a good exercise to help you to draw in continuous flowing line without taking your hand off the paper.

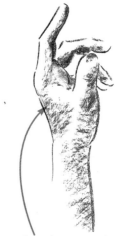

A short charcoal stick is used on its side to roughly block in areas of shading.

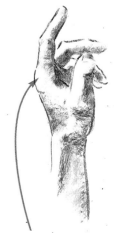

Continue to shade. You can lift out any lost highlights with a putty rubber.

DRAWING FEET

■ Feet are rather easier to draw than hands, as they are not capable of such complex movements. The fingers can manipulate a variety of objects in many different ways, but the toes are relatively static, their main function being to act as stabilisers.

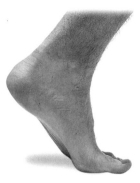

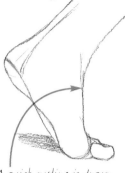

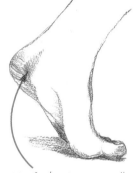

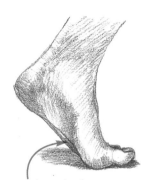

A quick outline is drawn using a sanguine Conté pencil. Notice how the outer edge of the foot curves up to the little toe.

Add soft shading gradually to build up a sense of volume and three-dimensional form.

Reinforce the shading on the darkest areas of the foot: on the heel, the sole and the arch.

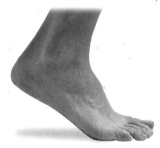

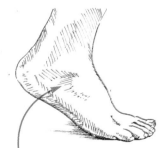

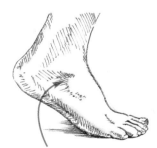

Try out different drawing media, especially ones that are non-erasable such as ink and pen, as shown here. This will help to build your confidence. First, draw a simple outline of the foot.

Wash water-soluble ink with a brush and clean water to provide tone. Draw light guidelines to give the direction of the ankle and foot, and then complete the outline, adding a cast shadow to ground the foot.

Areas of tone are defined by hatching while the darkest areas are worked up with crosshatching. Leave the lightest areas untouched so that the brightness of the paper becomes the area of highlight.

EXERCISE 12

Male and female eyes

by Lucy Watson

The basic proportions of the head vary a great deal less than the features themselves – no two eyes, noses and mouths are the same, and ears too are highly individual. If you are interested in portraiture you will need to analyse these individual traits, but always bear the underlying forms in mind as you draw and observe. The eyes, often called 'the windows of the soul', are always the focal point of any portrait study, so take time to study their unique characteristics before starting to draw. Consider their shape and size, whether they are spaced far apart or close together, whether they are heavy-lidded or set deep into the eye sockets.

STAGE 1
DRAWING OUTLINES

■ These drawings highlight the differences between male and female eyes by drawing attention to the structure of the eye itself and comparing the differences between an example of a heavily lidded female eye to the more deeply set eye of a male.

Female eye

Male eye

Practice points
- NOTICING INDIVIDUAL DIFFERENCES
- ANALYSING STRUCTURE
- USING SHADING TO IMPLY FORM

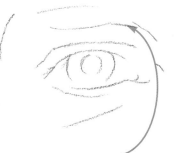

The lids of the female eye are very evident so this should be your first consideration when drawing the linear sketch. There is also some shadow under the eye so a line is marked in to define the area to be shaded at a later stage.

The male eye is deeply set with much of the area under the eyebrow cast in shadow. The linear sketch is drawn to reflect this, with the eyebrow line resting just above the eye itself.

The eyebrows are lightly sketched in at this early stage to help define the structure of the eye socket in which the eyeball sits.

Areas of hatched shading are added to the entire top of the eye under the brow, emphasising the deep shadows in and around this deep-set eye.

STAGE 2
ADDING SHADING

■ Shading is now added to the linear sketch to bring out the individual characteristics of the eye. To help you define this, use the trick of screwing up your own eyes, to bring out the areas of greatest light and dark contrast in your subject.

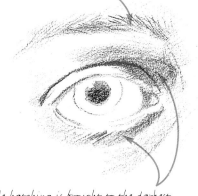

Some gentle hatching is brought to the darkest areas of the eye. These are frequently found in the corner of the eye nearest the nose and here shading is also added under the eye, helping to emphasise the spherical shape of the eyeball above.

The pupils and the iris are lightly sketched in. This brings a more realistic feel to the study.

STAGE 3
DETAIL AND DEFINITION

■ The final stage concentrates on building up shading, which defines the moulded contours of the socket. The eye colouring is now added, bringing greater impact to the study. Last but not least, the finer details of eyebrows and lashes are added in to complete the work.

Note how the hairs sweep around the eyebrow, helping to define the contour of the socket.

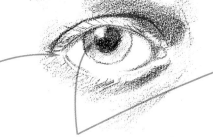

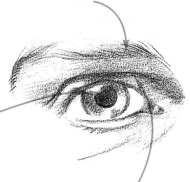

The inside of the lower lid is visible in this study and the eyelashes are added to its outermost edge.

It is most important to capture the glassy appearance of the iris through the use of sensitive shading. By concentrating on the iris alone, you will see how the colour is far from flat; in some areas it is dark, in others, light. A spot of white highlight enlivens the eye and prevents it from sinking back into shadow.

The lid almost disappears within the socket emphasising the deep-set position of the eye.

EXERCISE 13

Ears, noses and mouths

by Lucy Watson

Artists who gloss over ears, seeing them as unimportant – or too difficult – do so at their peril for they are missing an important opportunity to convey character. Try to see the ear's overall structure, with the ear radiating outwards from the orifice into which it channels sound to the larger part above and the lobe below. Concentrate, too, on exploiting the lights and darks that will give the ears the illusion of three-dimensional form. Similarly, to give form to a nose, you need to think in terms of tone rather than line. The top of the nose is part of the skull, but the rest, like the ear, is cartilaginous structure that varies enormously in shape and size from person to person. The mouth is the most mobile of all the facial features, its movement having a direct effect on the eyes, cheeks, nose and chin. For this reason, it is easiest to think of the mouth's size and shape in terms of its relationship to other features.

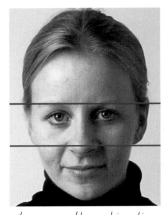

The ear, roughly speaking, lines up with the top of the eye and the bottom of the nose. Use this 'norm' to help you to spot individual differences.

DRAWING EARS

■ Like the nose, the ear consists of malleable cartilage, but is much more complex in structure. In the majority of drawings, giving an impression of the ear by concentrating on the lightest and darkest areas will suffice, but it is worth making some studies of ears to get to know the structure and to identify individual differences – these could be important in a profile drawing of a head.

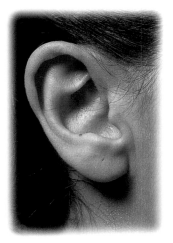

Make a light line drawing, roughly breaking the ear down into two rings, an outer and an inner.

Apply delicate hatching in the shadow areas of the ear to emphasise the sculptural form.

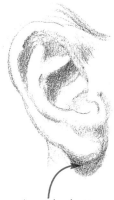

Work up the shading more strongly, and reinforce the shadow under the lobe to bring it away from the head.

DRAWING NOSES AND MOUTHS

■ Noses, mouths and chins should be drawn together, as they are inter-related, with the length of the upper lip and the space between the mouth and chin varying considerably from person to person. But first it is vital to understand the structures, especially of mouths, which are often drawn as straight lines rather than following gentle diagonal planes. As in the case of eyes, there are differences between the male and the female, but the structure is roughly the same.

<table><tr><td>**Practice points**
• SIMPLIFYING THE FORMS
• IDENTIFYING PROPORTIONS
• USING SHADING TO IMPLY FORM</td></tr></table>

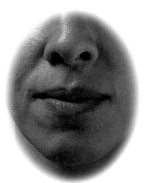
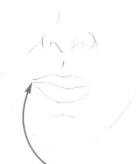
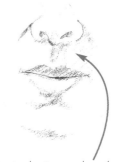

Women's lips are usually fuller than men's, and the jawline tends to be more heart shaped, finishing at the chin in a curved oval.

Start with a light line sketch to indicate the shape and position of the mouth, taking care to check the distance between the top lip and the bottom of the nose.

Begin shading to show the planes of the top lip and the side of the top lip, which is in shadow.

Continue to build up the forms, paying special attention to the 'Cupid's bow' above the top lip and the shadow beneath the bottom lip, as these define the form of the mouth.

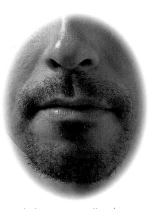

Male lips are usually thinner and flatter, and there is often a more pronounced line where the planes of the top lip meet the cheeks.

As before, start with a light line drawing to indicate the position of the nose and mouth.

Shade the nostrils and top lip, and reinforce the line of shadow where the lips meet.

Continue to emphasise the areas of shadow to build up the forms. This mouth is relatively full for a man, so there are pronounced shadows at the corners of the mouth and below the bottom lip.

FOCUS ON FIGURES
Composition

When you first start to draw, your efforts will naturally be channelled into the business of representing the subject accurately, and you may not think very much about the overall effect the drawing makes. But once you have overcome the initial hurdles, you will want to take a step closer towards picturemaking, and this involves thinking about how to compose the subject.

The boundaries

The edges of the rectangular sheet of paper provide the boundaries of your composition, so before you make your first mark, consider how you will place the figure or figures in this shape. A viewfinder is a great help here – hold it up to frame the subject, and move it around to help you decide on the composition. A seated figure seen from the side might be pushed to one side of the paper to emphasise the stretch of the legs, and a standing figure does not always have to be placed centrally. Think about how much space you should leave at top and bottom; a drawing can look cramped and uncomfortable if the head and feet are touching the edges of the paper.

Viewfinder *Make a viewing frame from two 'L'-shaped strips of cardboard. By moving one or both of the strips outwards and inwards, you can decide the crop of your final image.*

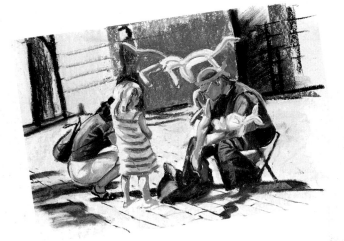

Making thumbnails *Three or four thumbnail sketches won't take long to complete and they give you the opportunity to test out different compositional ideas before you take your work further.*

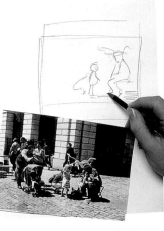

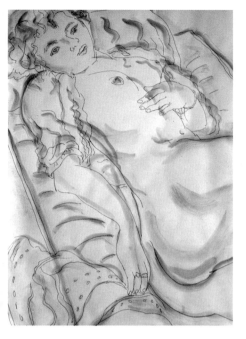

'Charlotte' *Cropping a figure can create an intriguing composition by focusing the viewer's attention on particular aspects of the subject.*

Cropping

If you are drawing a single figure, whether nude or clothed, remember that you don't have to include the whole body. Cropping the figure can make an exciting and powerful composition, for example in a nude study you might draw only the torso, or crop below the knees. Cropping needs to be planned with care, as it can look as though you have simply run out of paper, so use the viewfinder to decide which part of the body to focus in on to check whether it makes the kind of impact you are seeking. You might find it instructive to try out the idea on one of your old drawings, by cutting two corner pieces of paper or board and moving them around to crop the image in different ways.

Bringing in props

If you are drawing in a life class, there will be various objects such as tables, easels and chairs that you can include as part of the composition. The horizontal lines of a reclining figure might be balanced by the vertical lines of an easel behind the figure, or by those of a door frame, and you could bring in a horizontal – the line of the floor or a table top – to balance a standing figure. The same applies when you are drawing at home or outdoors; always look for features that may help the composition and make the drawing more interesting. For example, if you are sketching a person seated on a chair by a window, including at least some of the window frame will not only provide a contrast of shapes, but will also give the figure a context, and thus make the sketch more complete.

Multiple figures

The amount of thought you can give to composition when sketching outdoors depends on whether the figures are moving or still. Movement obviously has to be caught very quickly, but if you are sketching people in a café, or a family having a picnic, try to create a relationship between the people by including the table, packets of sandwiches or whatever it is that brings them together. This will bring a narrative, or story-telling element into your work and create more visual impact.

Interrupted view
This study of a nude was given added interest and drama by the artist's inclusion of several wooden easels in front of the model.

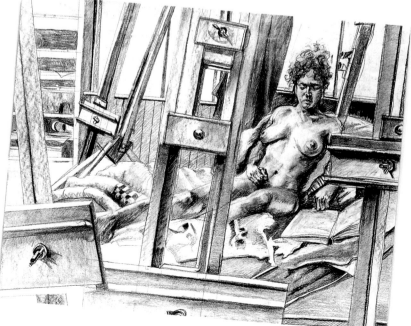

EXERCISE **14**

Café scene
by Hazel Lale

Café scenes are exciting subjects to draw and paint, even if their busy medley of compositional elements may appear daunting at first. If you break them down into bite-sized pieces, however, you will see all sorts of possibilities that you can tackle quite easily. Keep certain 'headings' in mind when you plan the picture, such as the focal point, with its associated shape and pattern, the light source, which creates form, and the overall colour scheme. In this scene, the two parasols in the picture's centre break the backdrop of strong verticals created by the buildings and tree. The artist uses a simple colour theme based on one primary colour (blue), with a little of the complementary yellows and oranges brought in for contrast. She is working in watercolour.

STAGE 1
STRUCTURE AND GUIDELINES

■ Once you have identified the main focal point – in this case the two seated figures on the right of the picture – make a pencil drawing, beginning with these figures, and drawing them one at a time, starting with the head of the right-hand man. Keep the drawing simple, but try to observe the positions, gestures and spatial relationships. These two figures provide a key to help you establish all the other shapes and sizes, including those of chairs, tables and background features. A busy composition like this can easily expand across the paper unless you make continuous checks as you draw.

Practice points
- **PLANNING THE COMPOSITION**
- **MAKING VISUAL CHECKS**
- **CHOOSING A COLOUR SCHEME**

Simplify the shapes of the parasols, but make sure the angles are correct. Check the sizes of the windows in relation to the foreground figures by measuring with your pencil (see page 11).

The heads of the background figures share the same horizontal line. Draw the heads before completing the rest of the figures.

The spacing between chairs and people is an important consideration, and requires careful checking.

Draw the chairs and the figures together, noting the exact points at which the shapes intersect one another.

STAGE 2
STARTING TO PAINT

■ Before you begin to paint, check the drawing carefully, making sure that everything is correctly placed. If necessary, eliminate any unwanted details such as cups and bottles. Identify the primary light source, which will dictate where to place the lights and darks, then paint the figures first with simple blue washes. When these have dried, work on the chairs, painting wet-in-wet.

TIP
When working wet-in-wet, lay on the lightest colour first and then add the darker ones. Dropping watery light colours into less diluted paint darks will create undesired backruns, sometimes known as 'cauliflowers'.

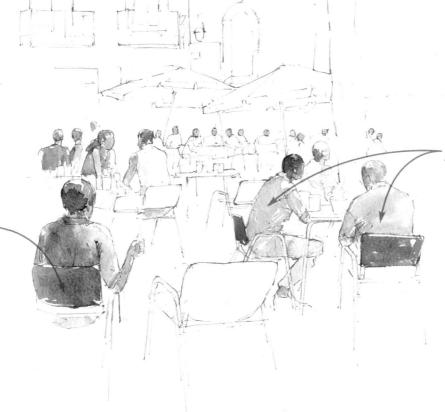

The direction of the light will alter as you work, so before you begin to paint, make an arrow in the margin of your paper to remind you where to place the shadows.

Vary the tones to suggest the shadows on the shirts, and leave white patches of paper as highlights.

To create more interest in this foreground area, lay a wet blue wash and drop greens and yellows into it while it's still damp.

STAGE 3
ADDING BACKGROUND COLOUR

■ Once you have decided the main elements of the composition, work around the sketch quickly, lightly washing in areas of tone. This brings cohesion to the work and establishes the natural light effects at an early stage before the light changes. Importantly though, some areas are left untouched so the brightest highlights appear in the finished piece; in this way the fresh anc lively nature of this sunlit scene is retained throughout.

Pale washes of terracotta are added to the buildings in the background. These warm shades contrast well with the cooler blue colours of the shadows beneath the large parasols.

Lay loose, wet background washes to give cohesion to the composition, and paint the windows with the same colour you used for the shirts. This creates a link between foreground and background.

The chairs are blocked in with bold tones. This brings a sense of space and depth to the scene as the chairs are casually dotted about between foreground and background.

STAGE 4
OBSERVING THE DETAIL

■ As you continue to paint, think about how much detail to include, and what purpose it will serve. It should always enhance the composition rather than confusing the image and thus reducing the impact. Objects such as the glasses and coffee cups will help the narrative, while extraneous elements such as lettering and graffiti can be left out.

This patch of sunlight makes a link with the white blouse, carrying the eye in from the middle ground towards the more distant figures.

The tree plays an important role, as it places the two main figures firmly in the foreground, but treat it lightly so that it does not become too dominant.

Painting objects on the tables helps to give a sense of life and activity.

Reinforce the wash around the chair legs so that the foreground chair stands out as a point of interest. Take care to preserve the white highlights.

STAGE 5
BUILDING UP TONE AND COLOUR

■ Now you can begin to build up the colours in the background and paint the foliage, which plays an important role in containing the scene, rather like a partial frame. Don't bring in too many colours, as the composition will hang together better if the same or similar colours are repeated from one area to another.

Paint the slanting shadow in a blue-grey, let it dry and then paint the foliage over it with the greens used for the foreground chairs. Work loosely, dropping touches of darker colour into the greens while the latter are still wet.

The warm red-brown and the ochres of the walls contrast with the dominant blues to give a sparkle to the painting.

Add tonal washes to the parasols to suggest the main shapes, but don't attempt precision.

The red blouses provide an understated colour accent, creating a secondary focal point in the middle ground.

STAGE 6
FINAL TOUCHES

■ Don't be tempted to go over the whole picture adding detail – the light, sketchy treatment is vital in conveying the feeling of relaxation, the essence of the lively, sunlit scene. Some areas do need strengthening, however, and the artist does this mainly by drawing over the colour with pencil. This is a very effective method, as it avoids overworking the paint by laying on too many layers.

Give form and definition to the windows to add background interest, and hatch in shadows to enhance the sunlit effect.

Add a little more colour, and when it is dry, draw some diagonal pencil hatching.

Emphasise the shadows with light hatching lines. Using lines that follow the same direction helps to give cohesion to the composition.

EXERCISE **15**

Balloon artist and child

by Mark Topham

This picture has strong contrasts of tone as well as bright colours, making soft pastels a good choice of medium. Not only can they achieve considerable depth of colour; they are also quick to use, and thus ideal for capturing the immediacy of outdoor scenes. Even if you are working from a photograph, the picture will appear livelier if it gives the impression of capturing a fleeting moment in time, and the artist succeeds in doing this by working quickly. He also gives the composition more impact by focusing in on the central group of figures and omitting much of the background.

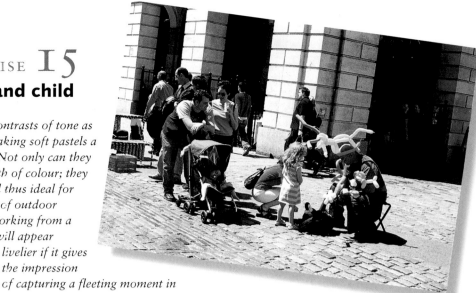

Practice points

• **CAPTURING THE MOMENT**

• **DECIDING WHAT TO LEAVE OUT**

• **USING STRONG CONTRASTS**

STAGE 1

WORKING OUT THE COMPOSITION

■ First decide how to place the figures against the background, and how much to include at the right and left of the central group. Notice how the artist is using only the shadows of the figures on the left, and has moved the dark area of background so that it falls behind the yellow balloon. When you have a definite idea for the composition, make a light drawing in pencil to establish the shapes and proportions before applying the key areas of colour.

suggest the main areas of background with black and warm grey, leaving the paper white where the yellow balloon is to go. Although pastel can be worked light over dark, you will lose the brilliance and purity of the colour if you try to work a very light colour over a dark one.

Using a bright red pastel, draw in the stripes of the child's dress, noting how they follow the posture and form. Use a light pink-red for the woman's blouse, blocking in the shape boldly.

To balance these first colours, mark in patches of bright colour for the man's face and the highlight areas of his shirt. These can be amended when you fill in the rest of the colours.

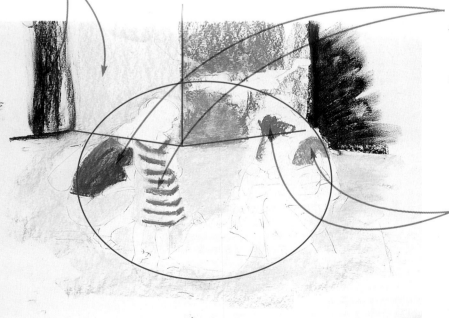

STAGE 2
THE TONAL FRAMEWORK

■ Because of the strong sunlight, the tonal pattern is an important feature of the subject, so give as much thought to the balance of tones as you do to the choice of colours. Remember that pastels are opaque, so if you make a tone too dark you can modify it by laying a lighter colour on top.

surprisingly fine lines can be drawn with a corner or broken edge of a pastel stick.

The man's clothes are predominantly dark, so bring in smaller dark shapes elsewhere in the picture to balance them.

Use a bright yellow for the balloon, leaving the edges uncoloured for the time being.

Mark in the paving stones with a sharp pastel stick. These help you to place the figures and establish their position in space.

STAGE 3
BUILDING UP THE COLOURS

■ Now you can begin to build up all the colours, including the flesh tones. Notice that some of these are in shadow and are thus a relatively deep and rich colour, a mixture of red and brown, while those in direct sunlight are much paler. The man is mostly in shadow, so you can block in his clothing with mainly dark and midtone shades.

To suggest the form and the direction of the light, lay some light pink between the darker pink stripes on the shaded side, and then put a second, paler colour on the hair.

Don't be afraid to use strong tonal contrasts in these areas, as this helps to give the feeling of bright sunlight.

To describe the fall of light and bring in variety, use two or three colours for each area — dark blue and purple over the green for the trousers, a very dark blue and lighter purple for the waistcoat (vest), and light and dark blue for the shirt.

STAGE 4
DEVELOPING THE PICTURE

■ Before working any further on the figures, you need to be able to see them in context, so put in the shadows next, starting with those beneath the man's feet and chair. The dark shadows play an important part in the tonal pattern of the drawing, and enhance the impression of strong light.

Pastels have very intense colours when applied thickly, and can be easily smudged with the fingers or a rag to cover large areas quickly.

When you have put in the shadow, continue to build up the colours on the man's clothing so that all the paper is covered in this area.

You can use artistic licence for shadows, as the artist does here, exaggerating the length so that the dark shape takes the eye into the picture from the foreground.

STAGE 5
ADDING DETAIL

■ Complete the shadows on the left of the picture before adding detail to the figures. In pastel work it is vital to leave any small linear detail until last, as the colours are so easily smudged – there is nothing more frustrating than finding you have accidentally wiped off an area of careful drawing.

TIP
Place a small piece of smooth paper under your working hand to prevent your picture from smudging as your work progresses.

To give a touch of definition to the man's face and arm and the figure of the girl, draw sharp, fine outlines with an edge of pastel.

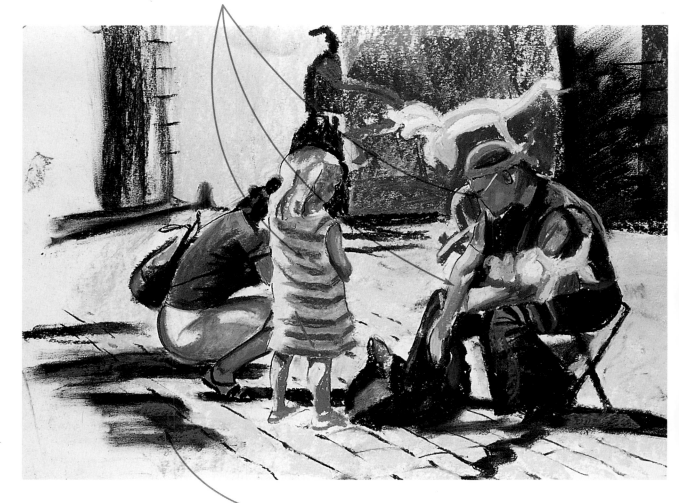

As you are not including the figures that cast these shadows, don't be too specific about them; just make broad, slightly varied strokes, softening them by smudging with a finger.

STAGE 6
FINISHING TOUCHES

At this stage, all that remains is to look at the picture with a critical eye and see whether further definition is needed to make sense of any of the shapes and forms. The artist notices that the balloons lack form, so he adds highlights to produce the effect of three 'stripes' along the length of each one, consisting of a dark, middle and light tone. He also darkens the background a little, and puts in small touches of detail to bring the figures to life and strengthen the narrative element of the drawing.

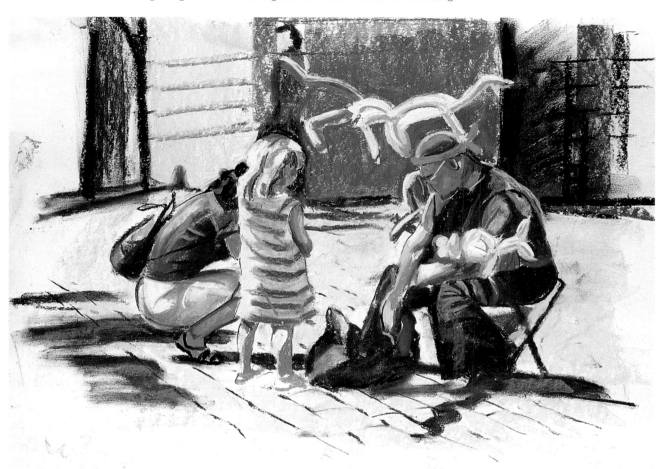

Add a few highlights to the paving stones to give them form, and brighten the colours by introducing purple into the shadows.

The yellow balloon provides an exciting colour accent, while the purple one sets up an echo with the woman's skirt, making a link between the two areas of the composition.

The spectacles and small highlight behind the ear describe the precise angle of the head and add extra interest.

EXERCISE 16

Market scene
by Hazel Lale

Busy scenes like this provide an abundance of different shapes, giving you an excellent opportunity to practise ways of organising the composition. Remember that you don't have to include everything you see, and you can move elements around or give additional emphasis to certain objects if it achieves a better overall balance. When drawing in monochrome – this artist is working in pencil and pen – you also need to consider the tonal pattern, so identify the main dark and light shapes and decide where to place them. To help you plan the composition, try to see the subject initially as an abstract design – a collection of shapes and lines rather than people, flowers and buildings. All successful compositions have an underlying structure that is satisfying in itself, regardless of the subject matter.

Practice points
- PLACING SHAPES ACCURATELY
- BALANCING NEGATIVE AND POSITIVE SHAPES
- EMPHASISING THE FOCAL POINT

STAGE 1
PLACING THE SHAPES

■ Start by marking the centre of the composition, as this helps you to place the shapes. Then identify the focal point, in this case the figure of the woman. Draw the head first, then mark a light guideline from it to the centre of the page to help you get the distance, angle and size of the head right. This is important, as this focal point will be the key to which all the other shapes are related. Continue to draw from the middle of the composition outwards.

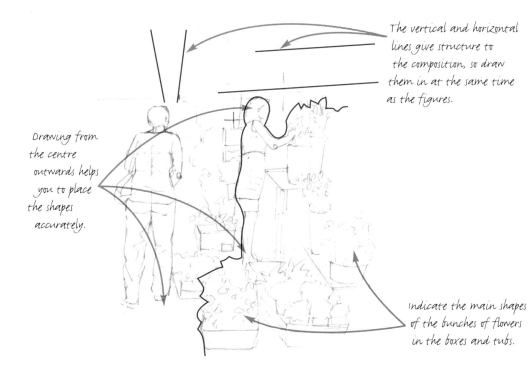

The vertical and horizontal lines give structure to the composition, so draw them in at the same time as the figures.

Drawing from the centre outwards helps you to place the shapes accurately.

Indicate the main shapes of the bunches of flowers in the boxes and tubs.

STAGE 2

BRINGING IN THE BACKGROUND

■ Once the main figures and foreground area have been outlined, the architecture and background can be sketched in. A strong sense of space and depth begins to appear in the work as the eye is led into the scene by the structural lines in the awnings and the scale of objects can be compared in background and foreground.

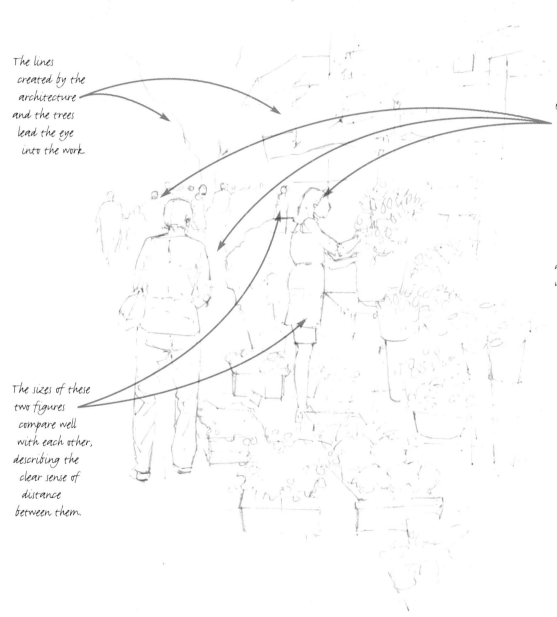

The lines created by the architecture and the trees lead the eye into the work.

Note that the figures are affected by perspective. The heads are roughly on the same horizontal line, while the feet are placed on an imaginary diagonal sloping upwards.

The sizes of these two figures compare well with each other, describing the clear sense of distance between them.

STAGE 3
FOREGROUND SHAPES AND PATTERNS

■ The boxes in the foreground provide an interesting contrast of geometric and non-geometric shapes that break up the space and lead the eye into the composition. Lightly draw in these pattern areas, checking sizes against that of the central figure, and then begin to indicate the midtones with diagonal hatching lines.

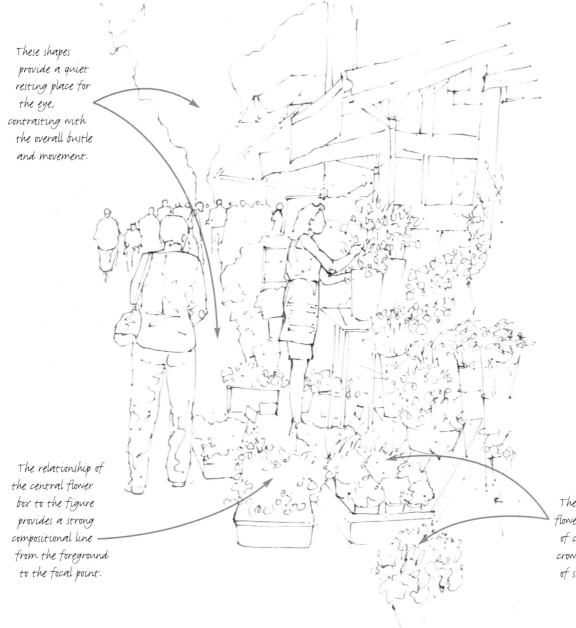

These shapes provide a quiet resting place for the eye, contrasting with the overall bustle and movement.

The relationship of the central flower box to the figure provides a strong compositional line from the foreground to the focal point.

The bunches of flowers form a series of conical shapes crowned by a mass of smaller ones.

STAGE 4
BUILDING UP TONE

■ Continue to add midtones all over the drawing, but take care to preserve the negative shapes (see page 21). A good balance between negative and positive shapes is especially important in a busy composition like this.

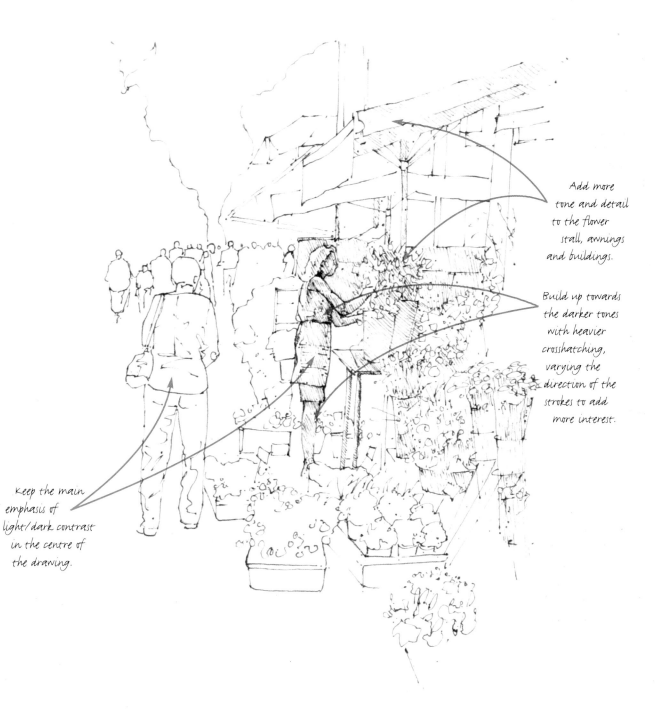

Add more tone and detail to the flower stall, awnings and buildings.

Build up towards the darker tones with heavier crosshatching, varying the direction of the strokes to add more interest.

Keep the main emphasis of light/dark contrast in the centre of the drawing.

STAGE 5
INCREASING THE CONTRASTS

■ As you darken the tones the areas of white paper become more obvious, but you can give them even more emphasis by drawing a continuous line around them.

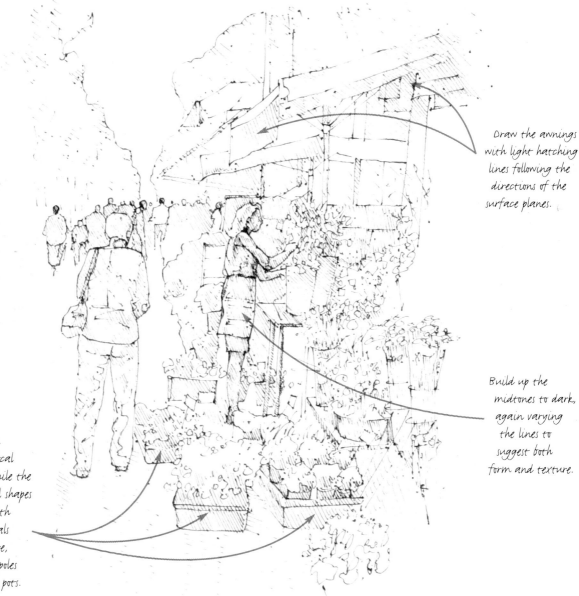

Draw the awnings with light hatching lines following the directions of the surface planes.

Build up the midtones to dark, again varying the lines to suggest both form and texture.

These darks make a link with the focal point, while the horizontal shapes contrast with the verticals of the figure, background poles and flower pots.

STAGE 6
TONE AND DETAIL

■ There is a mass of detail in the foliage and flower heads, but try to give a suggestion rather than an exact description, especially in the foreground. Too much precise drawing would steal attention from the focal point and reduce the impact of the strong tonal pattern. You can add a little detail on the figures as you build up the tones, but again, don't overdo it.

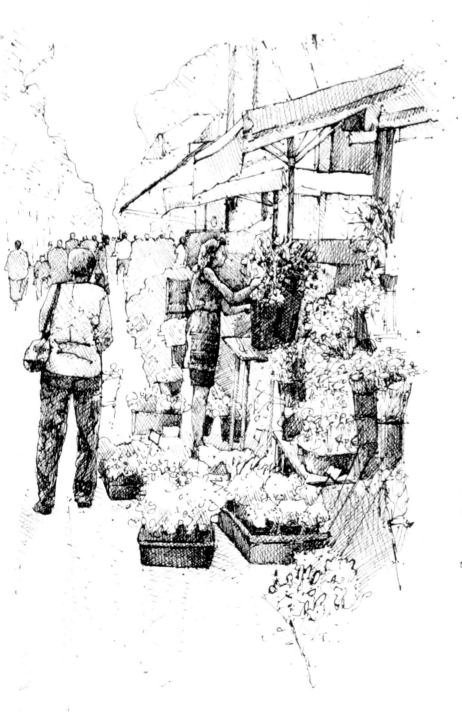

shading the background figures as one mass gives a sense of distance, separating background from middle ground.

Touches of detail on the clothing help to describe the forms and give the impression of movement.

As this is the focal point, you can put in more detail, creating extra interest and helping to draw the eye in.

Media Technique Directory

Dry media like wooden and carbon pencils, soft and hard pastels and coloured pencils are flexible tools for drawing and sketching. But wet media such as inks, oil pastels and watercolours present sketchers with an equally wide and expressive range of techniques.

Drawing paper and pads

The major manufacturers produce paper in both sheet and pad form, the latter being available in a wide range of sizes. Smooth drawing paper, in light-, medium- or heavy-weight form, is widely used for drawing with dry media and ink. Special papers are available for watercolour and pastel work.

WOODEN PENCIL

▼ A wooden pencil is a graphite strip sealed into a wooden case. It can be used on a variety of different surfaces to produce a wide range of linear effects. Note the difference between the lines made with a hard HB, a B, a 5B and a soft 7B pencil (top to bottom).

▼ Create areas of tone using a soft pencil. The heavier the pressure, the darker the tone.

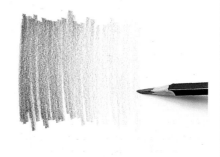

▲ Tone can be varied and lightened by blending different weights of pencil with a finger, torchon or soft rubber.

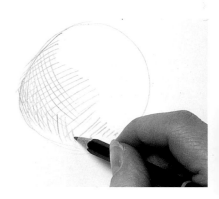

▲ Lines can be hatched or crosshatched with a wooden pencil to build up areas of varying tone and density. Pressure, speed of application and the pencil grade all have an impact on the final result.

▼ You can use a rubber to lift out areas of tone and create a variety of desired effects, including texture on clothing or the highlights on your model's body. Knead the rubber into a point for small details.

CARBON PENCIL

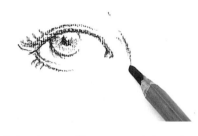

▲ A carbon pencil is compressed charcoal sealed into a wooden case. It is a soft pencil that produces a rich black line with very little pressure. Charcoal pencils are found in grades of soft, medium and hard.

CHARCOAL

▲ Thin stick charcoal produces expressive linear strokes, and thick marks can be made by using the charcoal on its side. You can vary the thickness of the stroke by changing the angle of the charcoal stick on the page.

▲ You can build up large midtone areas by using a charcoal stick on its side. Use the charcoal stick's breadth of mark to create large-scale works and its smoothness of application when working quickly.

▲ You can use your finger to blend different areas of tone together for a natural stic effect.

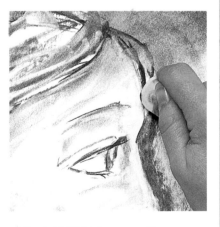

▲ Create highlights in an area of tone – or correct mistakes – by lifting out the charcoal with a putty rubber (knead the rubber into a point for small details). This can produce a variety of effects, from sharp lines to textures and highlights.

COLOURED PENCIL

▼ Coloured pencils are quick and clean to use, and easy to transport. All the traditional line techniques and marks that are possible with graphite pencils, such as hatching, can also be made using coloured pencils.

▼ Coloured pencils can also be used to colour in large areas.

WATER-SOLUBLE COLOURED PENCIL

▼ Water-soluble coloured pencils are a cross between coloured pencils and watercolour paints. You can apply the colour as you would with a coloured pencil and then use a soft watercolour brush dipped in a little water to dissolve the pigment and blend the colours together on the paper surface.

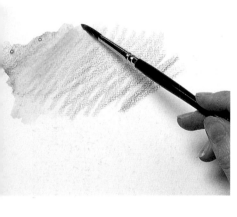

Pastel sheets and pads

Most pastel artists will use specially textured pastel papers that will hold several layers of dry pastel dust without becoming saturated. Pastel papers are available in a wide range of colours.

SOFT PASTEL

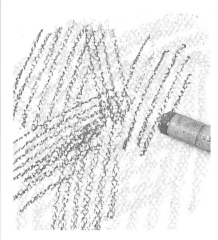

▲ Soft pastels are the most commonly used pastels and offer the largest choice of tints and tones. Crossing one set of hatched lines with another increases the density of colour and tone.

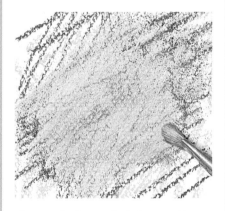

▲ Areas of colour can be built up quickly by blending with a dry brush. Pastels mix particularly well with other drawing media, including coloured pencil, watercolour and gouache.

▲ Side strokes can be used to lay in broad, sweeping areas of solid colour, or to scumble one colour over another.

▲ Areas of colour can also be built up quickly by blending with your finger.

HARD PASTEL

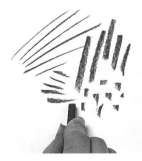

▲ Hard pastels are usually square, but can be sharpened to a point with a sharp craft knife. You can use the end or sharp edge of the pastel to create lines, strokes, dashes and dots.

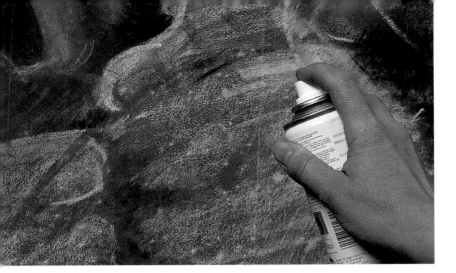

Using fixative

Fixative leaves a mat layer of resin that coats and holds any loose pigment dust in place. It is usually used with charcoal and pastel sketches. Fixative is available in aerosol cans, and in bottles that use a pump action or need a diffuser, and should always be sprayed away from the face and clothing.

CONTÉ STICKS/PENCILS

▼ Conté sticks are similar to hard pastels and are available in a range of traditional colours, including black, white, sanguine, sepia and bistre. Use a Conté stick on its side to produce blocks of solid colour.

▼ A Conté pencil produces finer lines than those of a Conté stick, suitable for drawing small details. You can also use your finger to blend Conté colour on paper.

OIL PASTELS

▲ Oil pastels can be opaque, semi-transparent or transparent. You can use them to make fine linear strokes, or on their side, as shown here, to block in broad areas of colour.

▲ The fatty consistency of oil pastels gives them great mobility on the paper surface and they can be layered one on top of the other to create rich, intense areas of colour.

▼ The consistency of oil pastels is perfect for creating effects with sgraffito, or scratching techniques, using a craft knife.

▼ You can rub oil pastels onto water-colour as shown here to create vivid and startling effects.

BALLPOINT PEN

▲ Although ballpoint pens produce lines of uniform width, the end result can look lively and spontaneous.

TECHNICAL PEN

▲ A technical pen delivers ink to the paper through a narrow metal tube, producing an even line of a specified width that is unaffected by hand pressure. It is ideal for detailed linework such as drawing hairlines.

▼ A technical pen can be used to draw in delicate hatching and crosshatching lines, suggesting shadow and subtle textural variations, as on a person's clothes, for example.

▼ Technical pens are either water- or solvent-based. If you use water-based pens, you can create interesting effects by using a brush to work into drawings with water.

MARKERS AND FELT-TIP PENS

▲ Markers and felt-tip pens are available in a wide range of colours, nib thicknesses and shapes. Here, a fine-tipped pen has been used to hatch and make marks.

▲ Use a wide-tipped marker pen to create solid blocks of colour.

Dip pens and ink

Dip pens that take interchangeable nibs are made from both wood and plastic. Shapes and sizes vary, so test out a few until you find one that is comfortable to use. Several different nibs may be used during the course of a single work. Waterproof inks are denser than the non-waterproof varieties, are capable of very precise work and dry to a slightly glossy finish. Non-waterproof inks dissolve if washed over with water and dry to a mat finish.

Watercolour paper

Watercolour paper is woven, acid-free and usually white. It comes in degrees of thickness and in three different textures: rough, cold-pressed and hot-pressed. Machine-made watercolour paper is the most inexpensive of watercolour papers, but may distort when wet. Mouldmade papers are more durable, and less resistant to distortion. The best but most expensive type is handmade.

▲ If waterproof ink is used, as here, watercolour washes can be applied to linework. If the ink is non-waterproof, essential marks may need to be redrawn when the wash is dry.

WATERCOLOUR

▲ A flat wash needs to be applied at a slight 20-degree angle. Load a large wash brush with paint and, starting at the top, make a steady horizontal stroke across the paper.

▼ Perfect for showing changes of tone, a graded wash is a variation on the flat wash. However, each time you make a horizontal stroke, add more water to the mixture, making it slightly lighter (or add more paint to make it darker).

Watercolour pads

Watercolour paper can be bought in separate sheets or in pads. Cold-pressed watercolour paper is widely considered to be the most versatile and easy to use.

▼ Brush masking fluid onto the paper on the areas you wish to preserve. Once the masking fluid is dry, it can be freely painted over as it acts a block to the paint. When the paint has dried, the masking can be removed by gently rubbing with a finger. Masking fluid ruins brushes for use in other work.

▼ You can apply wet paint to an area that is already wet with paint, a technique known as wet-in-wet. Depending on how wet the base layer is, the technique results in colours flowing and blending together.

▼ Wax resist, which can be candlewax, oil pastel or wax crayon, also blocks paint, but less completely than masking fluid, so it can be used to produce interesting effects. First, lightly draw or scribble with a candle.

▲ When you paint over the surface, the colour will slide off the waxed areas and into the paper grain, creating this wonderfully speckled effect.

▲ Fine white lines can be created by scratching colour away with a blade to reveal the white paper beneath. Let the painted surface dry completely, then use the point of the knife to scratch into it. This is a useful technique for creating highlights.

Stretching paper

Most paper will swell and buckle if it is wet. When working with wet media such as watercolour, stretch the paper in advance to avoid ruining your work.

1 Place your paper on a large board.

2 Measure and cut pieces of adhesive paper tape to fit around the edges of the paper.

3 Dampen the sheet of paper in a tray of clean water.

4 Lay the paper on the board. Dampen the strips of paper tape and lay a strip along each edge of the paper, with one-third of the tape covering the paper and the rest covering the board.

5 Smooth the surface of the tape down with the sponge. Gently wipe the excess water from the paper and leave to dry until the paper is taut. Remove the paper from the board by cutting away the tape with a craft knife.

Making a viewfinder

You can make a simple viewfinder using some cardboard (a cereal box is ideal), a pencil, a ruler and a pair of scissors.

1 Place the cardboard on a clean, smooth surface. Use a pencil and ruler to draw a frame about 5 centimetres wide around the sides of the cardboard.

2 Cut the cardboard along the pencil lines to create two 'L'-shaped strips.

3 Place the two 'L'-shaped strips over the image you wish to draw as shown, moving one or both of them outwards or inwards to decide the crop of your final image.

Acetate and tracing paper

Tracing paper is used to transfer drawings from one surface to another, while acetate is often used to make up grids.

Suppliers

Many of the materials used in this book can be purchased at good art shops. Alternatively, the suppliers listed below can direct you to the retailer nearest you

UNITED KINGDOM

Berol Ltd.
Oldmeadow Road
King's Lynn
Norfolk PE30 4JR
Tel 01553 761221
Fax 01553 766534
www.berol.com

Daler-Rowney
P.O. Box 10
Bracknell, Berks R612 8ST
Tel 01344 424621
Fax 01344 860746
www.daler-rowney.com

Pentel Ltd.
Hunts Rise
South Marston Park
Swindon, Wilts SN3 4TW
Tel 01793 823333
Fax 01793 820011
www.pentel.co.uk

The John Jones Art Centre Ltd.
The Art Materials Shop
4 Morris Place
Stroud Green Road
London N4 3JG
Tel 020 7281 5439
Fax 020 7281 5956
www.johnjones.co.uk

Winsor & Newton
Whitefriars Avenue
Wealdstone, Harrow
Middx HA3 5RH
Tel 020 8427 4343
Fax 020 8863 7177
www.winsornewton.com

NORTH AMERICA

Asel Art Supply
2701 Cedar Springs
Dallas, TX 75201
Toll Free 888-ASELART (for outside Dallas only)
Tel (214) 871-2425
Fax (214) 871-0007
www.aselart.com

Cheap Joe's Art Stuff
374 Industrial Park Drive
Boone, NC 28607
Toll Free 800-227-2788
Fax 800-257-0874
www.cjas.com

Daler-Rowney USA
4 Corporate Drive
Cranbury, NJ 08512-9584
Tel (609) 655-5252
Fax (609) 655-5852
www.daler-rowney.com

Daniel Smith
P.O. Box 84268
Seattle, WA 98124-5568
Toll Free 800-238-4065
www.danielsmith.com

Dick Blick Art Materials
P.O. Box 1267
Galesburg, IL 61402-1267
Toll Free 800-828-4548
Fax 800-621-8293
www.dickblick.com

Flax Art & Design
240 Valley Drive
Brisbane, CA 94005-1206
Toll Free 800-343-3529
Fax 800-352-9123
www.flaxart.com

Grumbacher Inc.
2711 Washington Blvd.
Bellwood, IL 60104
Toll Free 800-323-0749
Fax (708) 649-3463
www.sanfordcorp.com/grumbacher

Hobby Lobby
More than 90 retail locations throughout the US. Check the yellow pages or the website for the location nearest you.
www.hobbylobby.com

New York Central Art Supply
62 Third Avenue
New York, NY 10003
Toll Free 800-950-6111
Fax (212) 475-2513
www.nycentralart.com

Winsor & Newton Inc.
PO Box 1396
Piscataway, NY 08855
Toll Free 800-445-4278
Fax (732) 562-0940
www.winsornewton.com

Index

Credits

Quarto would like to thank and acknowledge the following for permission to reproduce the pictures that appear in this book.

Key: b=bottom, t=top, c=centre, l=left, r=right

Ines Allen 39(b), 69(bl,br), **Harry Bloom** 75(tl,bl), **Julia Cassells** 1, 6(tr), 7(b), 32(b), 33(tr), **David Cottingham/Represented byBenaki Modern Art, London** 33(c), 83(tl), **Barry Freeman** 3(tr,bl), 8 (inset), 39(t), 51(t), 58(bl), 59(tr), 68(bl), 69(tr), **Ruth Geldard** 21(tl), **Maureen Jordan** 38(b), 50(t), **Clarissa Koch** 59(bl), **Hazel Lale** 4, 9, 67(inset), **David Martin** 69(tl,tc), **Mark Topham** 66, 82(bl), **Lucy Watson** 10(bl), 20(br), 21(br), 38(t), 67(inset), 74(tl,bl), 83(br), **Valerie Wiffin** 75(cr).

All other photographs and illustrations are the copyright of Quarto Publishing plc. While every effort has been made to credit contributors, we would like to apologise in advance if there have been any omissions or errors.